Doodle Healing

A Fun, Easy, and Effective Strategy to
Design a Life of Joy,
Self-Compassion & Purpose,
No Matter Your Circumstances.

Cindy K Bayles
FLC, HJC

Doodle Warrior University

A Gift For You!

Discover how our **Doodle Warrior**

program has helped women create lives of

Joy, Self-Compassion & Purpose.

Access this **Bonus Video Training** on the three steps to start creating a life you never dreamed possible.

But wait there's more!

*Also get this FREE BONUS: The Doodle Healing Workbook. Which includes worksheets, habit tracker, journal prompts, and coloring pages.

All yours FREE with this book.

DON'T WAIT!

Watch this FREE VIDEO TRAINING now,

And start living a life of Joy, Self-Compassion, & Purpose

https://doodletherapy.groovepages.com/book-free or use this QR code.

Doodle Healing
Cindy Bayles

Copyright ©2023 Cindy K Bayles, FLC, HJC
All rights reserved.
Printed in the United States of America. No part of this book may be used or reproduced in any manner whatsoever without written permission from the author.

Disclaimer

This book is for educational purposes only. The views expressed are those of the author alone. The content of this book is for informational purposes only and is not intended to diagnose, treat, cure, or prevent any condition or disease.

Layout and Design: Cindy K Bayles
Cover: Cindy K Bayles
ISBN: 979-8-9892916-0-1

DEDICATION

The artist inside all of us. May she create a life of purpose, self-compassion, and joy, no matter her circumstances. So, she can change the world.

To my children, may you know that it is within your power to have any life you desire. You decide what you think, how you feel, and what you choose.
Those simple choices build your life.

To the love of my life. Thanks for sticking it out with me. It's been the adventure of a lifetime.
I love doing life with you.

CONTENTS

Preface, ix

How Doodle Healing Works, xi

Section One: Doodle Your Heart, 1

• Chapter 1: Doodle You, 3

• Chapter 2: Doodle Love, 21

• Chapter 3: Doodle Joy, 41

• Chapter 4: Doodle Hope, 61

Section Two: Doodle Your Mind, 79

• Chapter 5: Doodle Boldly, 81

• Chapter 6: Doodle Thoughts, 99

• Chapter 7: Doodle Story, 119

• Chapter 8: Doodle Vision, 137

Section 3: Doodle Strength, 155

• Chapter 9: Doodle Crown, 157

• Chapter 10: Doodle Healing, 177

• Chapter 11: Doodle Focus, 197

• Chapter 12: Doodle Warrior, 215

About the Author, 234

Acknowledgments: 237

Doodle Healing

A Fun, Easy, and Effective Strategy to
Design a Life of Joy,
Self-Compassion & Purpose,
No Matter Your Circumstances.

Cindy K Bayles,
FLC, HJC

Preface

In 2014, my world changed forever. I was devastated when my husband of 29 years asked for a divorce. At that moment, I knew nothing would be the same again.

I would have to decide who I would be, what I would do and how I would proceed. During the previous 29 years, I had given up the power to create my life. It was time to take responsibility for everything that was and would be in my life.

This book is not about my marriage and how we healed it. This book is about how I healed myself by taking responsibility for my thoughts, feelings, actions, and results.

Long before this, I had searched for something that would "fix" me. I had tried losing weight, going back to school, taking self-improvement classes, and reading self-help books. But none of these made me any different. They just made me frustrated.

Before I found doodling, I felt useless, worthless, and hopeless.

Doodles were the missing piece for me. Where before I wandered aimlessly from tool to tool; doodling my thoughts and emotions helped me see how I had the power to create different outcomes. Doodles pointed to the way out.

Before doodling, I woke up every morning thinking *"I am struggling."* That thought created feelings of despair and as a result, I continued to struggle. I struggled with my relationships, my self-worth, and making marks in my life.

Before doodling, I was afraid to make any kind of mark.

Whether that mark was on the page or my life. I was afraid of making mistakes, looking stupid, and being seen.

Through doodling, I gained courage and confidence and saw myself as worthy, heard, and valued.

Using the processes in this book I went from victim to doodle warrior. A doodle warrior stands in her power, embraces the future and is proud of where she has been.

Doodling, and the tools in this book, saved my life, my marriage, and my future.

You can be a Doodle Warrior too!

You already have the tools! You simply need your mind, heart, pen, and paper.

I know you can create a life of joy, love, purpose, and creativity. I know because I did. I went from struggling to thriving.

Doodling can change your life too!

How Doodle Healing Works

What you can expect from this book.

Doodle Healing was created to be interactive. This book is an experience unlike anything you have seen before!

You CAN just read the information. The book is definitely packed with timeless principles. You will gain powerful tools by just reading. But when you engage with the doodles, magic happens.

By doodling along, you will dig deeper into the concept and see how it has and can impact your life. Doodling is fun, easy, & effective. It is a tool that works faster and more efficiently than anything I have ever seen.

As you doodle along with me, you will have A-ha's and perspective shifts that will change the way you see yourself and your life.

Grab your doodle tools and let's change your life. One doodle at a time.

Doodle Healing was created to be interactive. This book is an experience unlike anything you have seen before!

Each chapter is a step toward uncovering the unique person you are. A person equipped with tools to live a happier, fuller, life. I used these tools to change my own life. A life that unrecognizable from my former life.

DOODLING CHANGES YOUR BRAIN

Increased Mindfulness.

Mindfulness is defined as being aware of our thoughts, feelings, body, and environment. When doodling, we learn to be gentle with ourselves with our circumstances, thoughts, and feelings. When we meditate and our thoughts wander, we can just "begin again." This allows us to be human and make mistakes without fear or judgment.

Cognitive Behavior Tools or CBT.

CBT is a tool that therapists commonly use. This tool helps patients to reframe their thoughts. But we don't have to wait for a therapist, we can practice using this tool today! **Cognitive** means what the brain thinks, dreams, or pays attention to. **Behavior** refers to the actions or inactions we take. When we change our thoughts, we get to the root of the problem. We have more power over our thoughts than we ever thought possible. And because of this, we can teach our brains to respond in new empowering ways.

Compassionate Change.

We can beat ourselves up or we can use **compassion** to create change. It's time to treat ourselves differently. How would it feel to stop beating yourself up and start loving ourselves instead? No change necessary.

Radical Questioning.

We don't often ask ourselves empowering questions. Instead, we ask questions like "Why me?". This is an unhelpful question. However, when we ask powerful questions, we get powerful answers. Answers that can change our lives. One **radical question** is to ask, "How is this happening FOR me?" This question makes us stop and look for what we can learn or gain from a situation.

Compassionate Witness.

Using the power of creativity, we give ourselves the gift of becoming **compassionate witnesses** for ourselves. Many of us yearn for someone to see, hear, and understand our pain. When we act as a witness, we are uniquely qualified to understand our pain and to help ourselves begin to heal.

Divine Scientist.

Experiment with new things without feeling bad when they go wrong. **Divine scientists** look at everything as just data. Our emotions are no longer tied to the outcome. We are just scientists trying to see what will happen with the next experiment.

Daily Mental and Emotional Hygiene.

We have neglected our emotional and mental hygiene for far too long. It is time to take ownership of cleaning out our brain and choosing our thoughts with purpose. Daily mental and emotional cleaning is the key to lifelong mental and emotional health.

Supply List

You will need:
- Open heart
- Open Mind
- Pen
- Paper

Optional Supplies that will be listed with the individual doodle.

- Watercolors
- Crayons
- Markers
- Scissors
- Glue

Yep! That's it.

If you want some color, use crayons, watercolors, any kind of paints, markers, dry erase markers, or colored pencils. Whatever makes you happy.

> You can get the list of my favorite supplies when you download a free copy of Doodle Healing Workbook at this link:
> https://doodletherapy.groovepages.com/book-free

This is your chance to be a kid again, relax this is going to be fun. There is no wrong way to do this. We are just making marks on the page. It's time to drop the perfection, comparison, and criticism. It has never served you anyway. At the end of each chapter, you will find a Doodle Activity.

Each activity will walk you through a doodle about each chapter's lesson. Don't stress. Just follow the instructions and allow yourself to play. You can't do this wrong just let your guard down and see what happens.

Section 1

Doodle Your Heart

I feel ...

1
Doodle You

"Every child is an artist. The problem is how to remain an artist once we've grown up."
~Pablo Picasso

Who do you think you are?

Who Am I?

The resume in front of me was discouragingly blank. I didn't think I had anything to offer a prospective employer. Why would anyone want to hire me? As a stay-at-home mom of nearly 30 years, I believed my options were limited. But I needed a job.

My husband had asked for a divorce, spoken to an attorney, quit his job, and filled out the divorce papers. He just needed my signature.

As a police officer's wife and mother of six, my goal had been to be a great spouse and mom. I labeled myself of failure!

"Shoulding" all over myself.

I had other labels I used to describe myself. Labels such as problem solver, unwanted, uneducated, victim, not good enough, mediocre, dumb, unworthy, and overwhelmed.

My inner critic mocked me. She whispered. "You **should** have finished college." "You **should** have kept working". "You **should** have been a better wife." "You **should** have…" ad nauseam.

With every "should have", I was further convinced of my worthlessness. Armed with my trusty labels and should-haves ringing in my ears, I headed out to find a job.

You are who you think you are.

Do you know what I found? A job that didn't require an education, was looking for a victim, needed a problem solver, and paid less than my value.

Do you know why that's what I found? **Because that's who I thought I was.**

Like me, the women I helped at that job, didn't think they were worth the effort. They said things like "I could never do that." And "I am not good enough." All while wishing and longing for something more.

Those women clung to their labels just as desperately as I clung to mine.

Are you worth the effort?

However, I saw their light. I saw their strength. I saw the hope in their eyes. I saw the power they had to change their world and THE world. But they were blind to it all. My beautiful friends couldn't see their value.

Witnessing their struggles, I took a hard look at myself. I had spent my life wishing and hoping that I was worthy enough to be noticed, respected, and loved. So, I asked myself, "What makes a person worthy?" Thus began my journey to figure out if I was worth the effort.

Pain Relief.

I tried going back to school and finishing my college degree. Getting a degree was great, but it didn't make me feel more valuable.

So, I took countless courses trying to "fix" myself. I learned valuable new habits, tips, and tricks. But those tools didn't improve the way I saw myself. There was no relief from the pain of being me.

I was on a mission to find something that worked from the inside out, changed the way I saw myself, and acted fast. That's a big ask, I know. Could one thing meet all of those requirements?

The Power of Creativity.

Born to Create.

In an effort to spark some joy, I enrolled in an art class. As I started creating, I let myself have some fun, released a little perfectionism, and let go of trying to fix myself.

As I painted, something inside of me began to stir and I recognized the importance of creativity in my life. Not just in my life but in everyone's lives. We are born to be creators. Our creative powers are God given gifts. We can choose to use these gifts for good or ignore them all together.

Benefits of Creativity.

According to multiple scientific studies, a creative outlet is essential to psychological and emotional health. Creativity benefits are many.

Creative pursuits like doodling help focus our minds, has been compared to meditation because it calms the brain and body, and releases dopamine, a natural antidepressant that decreases anxiety and depression.

Creativity Boosts Brain function.

Being creative makes it easier to learn, solve problems, and enhances critical thinking skills. A study published by the LEGO foundation found that people learn best through play. Doodling is a form of play.

Research from the Mayo Clinic indicates that being creative helps adults delay future neurodegeneration, lowers blood pressure, and improves the immune system.

Lost Imagination.

In 1968, a study conducted by NASA found children's creativity and imagination decline severely as they age. 1,600 4 to 5-year-old children were given a creative genius test. Of those 1,600 children, 98% scored at the creative genius level. 5 years later, when the same children were tested again, only 30% reached the "creative

genius" level. And it get's worse. That percentage dropped to 12% when the same children were tested as 15-year-old.

By the time children reach adulthood, only 2% are considered "Creative Genius" test.

- Age 4-5: 98%
- Age 10: 30%
- Age 15: 12%
- Adults: 2%

These children never recovered. By the time the kids reached adulthood, only 2% tested as "creative geniuses". Yep, that's it. As we age, we relegate imagination and creativity to childhood games, old-fashioned pursuits, and dusty t-parties.

Just Start.

I stopped creating because I believed, I didn't have the time, I would mess it up, and I didn't have anything to offer. I was afraid to try, to believe, and to dream. When I decided to create a different future, I had to change the labels I had for myself. I tried to go from believing I was unworthy to knowing I was worthy overnight. But that didn't work. I had to start with something believable for me.

So, I used modifying words such as maybe, might, and it's possible. Instead of saying I am creative! I said, "Maybe I can create something." I took baby steps toward my dreams and gained hope of a new future.

What Happened to Creativity?

Fear of Creating.

There are many excuses that keep us from creating. Time, money, space, knowledge, etc. These sound like legitimate excuses. I don't have enough time right now. I don't have enough money to get started. I don't have room in my house. Or I need to learn more before I can start. Does this sound familiar?

These were my excuses. But these are just excuses. The real problem is fear.

- Fear of failing.
- Fear of choosing.
- Fear of being uncomfortable.
- Fear of being seen.
- Fear of rejection.
- Fear of being unworthy.

> **The real problem is fear.**
> **Fear of failing.**
> **Fear of choosing.**
> **Fear of being uncomfortable.**
> **Fear of being seen.**
> **Fear of rejection.**
> **Fear of feeling unworthy.**
>
> *Cindy Bayles*

Fear of Rejection.

Humanity was built on communities. Those communities had expectations. When someone went against those expectations, banishment was often the punishment. Banishment meant almost certain death.

So, when we show up differently, it can feel like we are risking rejection. When someone rejects something we create it hurts. So, we ignore new ideas, promptings from God, and changes that are good for us in the name of fitting in.

But rejection is part of life. We each have different thoughts, beliefs, and views. So, it's good if someone loves our work and someone hates it. It means we're doing something right.

Choosing Labels.

Our labels can become a self-made prison.

Cindy Bayles

What we believe about ourselves can become a self-made prison or a path to freedom. My labels kept me from trying new things, from seeing my strengths, and from leaving my self-imposed prison.

We use labels to identify who we are. We don't have to keep any belief that doesn't serve us. We lack creativity not because we can't create. But because we have decided we are not creative.

Ask yourself:

What labels do I have for myself?

Who do I think I am?

Who do I think I am not?

Do I like my labels?

Are my labels serving me?

Inner Critic Radio.

There is a voice inside our heads that criticizes us. She is there to keep us safe, comfortable, and invisible. She is our Inner Critic Radio. IC Radio for short. Her voice is powerful.

Never listen to anyone that tries to mute your *light*

Your Inner Critic Radio may sound like your friend. Her voice may sound like your voice. But beware! She is not friend material.

Cindy Bayles

She is a dream killer. She says, "I see your mistakes. I see you're not good enough. I see you don't have time for that." She may sound like your friend. Her voice may sound like your voice. But beware! She is not friend material. Don't listen to anyone that tries to mute your light.

No Fixing Required.

As I let go of comparison, I found joy. Joy in being me. Life became lighter and freer. When we shine our unique light, we light the way for others. Creation is exhilarating, surprising, messy, and life changing. There is no progress in comparison.

> **Your unique *light* gives others courage to shine their beautiful *light* as well.**
>
> *Cindy Bayles*

When we compare, we judge ourselves inferior or superior to others. There are 400,000+ varieties of flowers. Every individual flower is uniquely different. How boring this world would be if every flower (or person) were the same. Imagine that sunflowers were all that grew on the earth. Pretty boring. Variety is what makes our world beautiful.

Every flower has beautifully distinctive characteristics. Put on this earth to serve its own purpose. God made you exactly as you are supposed to be. Our flaws and strengths make us interesting.

> **God didn't make a mistake when he created you.
> Your flaws AND your strengths make you perfectly, uniquely you.**
>
> *Cindy Bayles*

Doodling is Powerful!
Powerful People Doodle!

What do Marie Curie, Einstein, JFK, Edison, and Henry Ford have in common?

Doodling!

Really!

There are many benefits of doodling:
- There is no barrier to entry.
- Anyone can do it and the tools are minimal.
- Reduces Stress.
- Promotes creative problem solving.
- Improves memory and brain function. People who doodle retain 26% more information than people who don't doodle.

- Improves focus and concentration.
- Measurable change in our physical and neurological state.
- Can be done anywhere.
- It's an uncomplicated way to be creative.

Cavemen Doodled. You Can Too!

"But I can't draw!" you say?
Cave doodles were the human race's first doodle recordings. If the caveman can doodle, you can doodle too! All you need is paper and something to make marks with.

A pen, marker, crayon, dry erase marker, paint brush, use what you've got. No artistic ability required.

When humans abandoned cave drawings to the written word, we lost valuable parts of our written communication. When you doodle, your mind becomes deeply focused and relaxed. Harvard cardiologist, Herbert Benson identified this as the relaxation response. Doodling can be a meditative experience.

> **CAVE DOODLES WERE THE HUMAN RACE'S FIRST DOODLE RECORDINGS. IF CAVEMEN CAN DOODLE, YOU CAN DOODLE TOO!**
>
> --Cindy Bayles

Doodling my thoughts, emotions, and actions was new to me. As I doodled, I healed my relationship with myself, with God, and with my past. I became a compassionate witness to my own pain. I began to see myself as worthy, whole, and valued. It was the start of creating a life of compassion, joy, hope, and vision.

Because I showed up differently, the people I loved showed up differently too. As my joy rose, so did the hearts of those around me. It is miraculous to watch how the changes in me changed the people I loved.

> **I began to see myself as** worthy, whole, and valued. **It was the start of creating a** new life **for me.**
>
> Cindy Bayles

I Heart U Radio.

Doodling is a fun way to start making marks on the page. There is nothing to be graded on. There is no right or wrong. Life is meant to be created with joy and purpose. When your IC Radio booms "You can't!" Change the channel! Choose a new station. One that love you, encourages you, and makes you want to sing and dance. Your new radio is the I Heart U radio.

This radio encourages you with songs like. *"Don't stop now!"* "The doodle song" And *"I love and accept you."* Don't do life without an I Heart U radio. Kick the Inner Critic Radio to the curb.

> **I HEART U RADIO**
>
> **Change the channel! Choose a new station. One that** *encourages* **you,** *loves* **you, and makes you** *sing* **and** *dance!*
>
> *Cindy Bayles*

Make Your Mark.

Doodling is a magical creative outlet. Through doodling I made real marks in my life. Those marks were timid at first, but have become louder, bolder, and braver. Louder to share my message, bolder to speak my truth, and braver to be myself.

I dropped the labels that kept me imprisoned and chose new empowering labels. Labels that pointed me to undreamed-of places. Labels that encouraged me to explore unknown lands. Labels that set me free.

It starts with making marks on the page. Make them bold. Make them loud. Make them raw. Most importantly, make them real.

A Doodle A Day.

Sharpen the Saw.

How do you take care of your mental health? Steven Covey explains that it's smarter to cut down a tree with a sharp saw instead of a dull saw in his book "The 7 Habits of Highly Effective People". Doodling your thoughts and emotions sharpens the saw.

Doodling combines:
- Mindfulness
- Daily mental hygiene
- Cognitive Behavior Tools (CBT)
- Compassionate Observer
- Scientific Curiosity
- Radical Questioning
- Self-Compassion
- Reframing your past/trauma

Calendars Save Lives.

My day went something like this. Wake up. Put out the fire. Put out another fire. Get burned alive. Collapse. Rinse and repeat. There was no time to take care of me.

If I was going to **sharpen my saw**, I had to do something radical. I had to **SCHEDULE** time for me. I had to show up like my life depended on it. Because it does. Self-care has been clinically proven to reduce heart attacks, strokes, and cancer (as well as husband deaths). (More on self-care in chapter 6.)

My ongoing thoughts used to be "You can do that after you finish working?"

Scheduling time for me was a struggle. I believed rest and renewal came AFTER the work was done. Truthfully, the work is never done. This kind of mindset just leaves an exhausted, cranky woman.

> **I had to do something radical.**
> **I had to SCHEDULE time for me.**
> **I had to show up like my *life* depended on it.**
> *Cindy Bayles*

Rising Joy, Raises All Hearts.

Creativity creates a space to make decisions, make mistakes, and create joy. It's a time to check out and gain a new perspective. I kept hitting a brick wall over and over and over again. Now, I use doodles to help me see things from a different perspective.

The more I created, the more joy soaked into my soul. (Chapter 3) And the more joy I had, the happier those around me were. Rising joy raises all hearts. It's a never- ending cycle. Doodling can be a miracle in your life too.

15 Minutes A Day.

Give yourself 15 minutes of focused, uninterrupted time to create every day. Then see what happens. You might create a powerful life purpose (Chapter 4) or you might create a new vision for your future (Chapter 9).

In Chapter 2, I will show you how to love and accept yourself. No fixing required. Or start healing from trauma in Chapter 10. This book is written for action. But without planning, nothing happens.

Trust me. 15 minutes doesn't seem like enough time to make a difference, does it? It takes longer to clean the bathroom. At least my bathroom...

Doodling Creates Miracles.

With your schedule in hand, you cannot fail. In Chapter 12 we will talk about the power of one thing and how to become a doodle warrior (Chapter 11) Chapter 5 has some surprisingly simple ways to change habitual negative thoughts.

I am excited about the journey before us. You will see yourself and your future differently when we reach the end. Chapters 7 & 8 are about changing our stories and living boldly. You don't want to miss any of it.

You too can create miracles in your life. Miracles you might think are unattainable. Miracles only you were meant to create.

Let's get started creating miracles! 15 minutes at a time.

Doodle Activity
Unstuck Doodle.

Doodle along with me as we doodle what is keeping us from creating a life we love.

Supply list:
- 1 Mixed media paper or copy paper.
- Watercolors.
- Pencil.
- Waterproof fine tipped marker.

1. Lay an 8x10 sheet of paper horizontally in front of you.
2. Draw a line down the middle of the page.
3. Divide the left side into thirds horizontally.
4. In the second box, paint some random smallish circles. Don't stress. Just start making marks. In the top rectangle draw a bunch of small rectangles and a set of eyes peering out from behind the rectangles.
5. Inside each label write a label that you have for yourself.
6. In the last rectangle, doodle a boombox with poop emojis as speakers.
7. Doodle poop emojis coming out of your boombox. Beside each poop emojis, write what they say to you.
8. Go back to the second rectangle. Using the examples of flowers in the workbook, turn each circle into a flower. (Click the link below to access the workbook.)
9. Create a doodle of you on the right side of the page. To doodle you, use circles, triangles, and lines.
10. Doodle you holding a sign. Choose a label that empowers you and write your new label on the doodle sign.
11. Now doodle a second radio with heart speakers and doodle hearts coming out of your radio.
12. Name of your station the I Heart U radio.
13. What song does your hearts sing to you?
14. Draw a clock next to doodle you. And set the time you will show up for you.
15. Hang your masterpiece where you can see it. This is a reminder of your commitment to yourself.
16. Take some time and color or paint your doodle.

Unstuck Doodle

This is an unfinished Doodle YOU. You can use it as a guide, finish it, and/or color it.

Download a free copy of Doodle Healing Workbook at this link:
https://doodletherapy.groovepages.com/book-free
You will find space to journal, finished doodles, and doodle flower

2
Doodle Love
♡

"I learned a long time ago the wisest thing I can do is be on my own side."

~Maya Angelou

Stand Back And Squint.
Learning to Paint.

As a young mother, I joined a neighborhood watercolor class taught by a local artist. We met weekly in our teacher, Shanna's basement to paint, talk, laugh, & cry.

Shanna taught us to see the world differently. She taught us how contrast is important, how to look for the details, that it's just a piece of paper, and to stand back and squint. We learned when people see a painting, people see the painting as a whole. So, when looking at our own art, we needed to stand back and squint. Then we won't focus on our mistakes because the mistakes become part of the picture.

Masterpieces.

During those painting classes, we attempted a variety of paintings. From baskets of tulips to Christmas cards. Some of my "masterpieces" still hang in my home today.

As I gained confidence, I had a vision of painting something grander. I wanted to paint the Mesa, Arizona Temple. It would be a Christmas gift for my grandmother. She loved art, the temple, and me. So, it was the perfect gift.

I was nervous about tackling such a big project, but Shanna assured me it was possible. So, I prepped the canvas and prepared to create a masterpiece.

Purple Stains.

As the weeks passed, my painting started to look like a building. One night, I worked tirelessly on my masterpiece. As I stepped back to admire my progress, I was shocked by what I saw. There staring back at me was a deep purple stain. A purple stain where a purple stain shouldn't be!

When I paint, I like to remind myself that "It's just a piece of paper." That way, it's not huge when I mess up. I can just throw away the paper and start again. But this painting wasn't just a piece of paper. This was a big deal!

Mistake Making.

How could I start over? I had spent weeks working on it. I beat myself up for not paying attention. I thought:

"What was I thinking?"
"I shouldn't have worked on it alone."
"I should have paid attention. How do you paint purple in the wrong spot?! I should just give up!" On and on I went.

I beat myself up when my husband asked for a divorce. I berated myself in the same way I berated myself about the painting. I should have known better, done better, and been better. I should have seen where we were headed.

Love and Acceptance.

I thought I needed to be a certain way to earn love. So, I tried to please everyone around me. I was a people pleaser. People pleasers sacrifice their own needs in order to keep the peace.

My thoughts were:
- I can't have nice clothes until I lose weight.
- I am not good enough.
- My needs don't matter as long as everyone is happy.
- I need to be better.
- If I am not perfect, I am not worthy of love.
- I can play when ALL my work is done.

These thoughts kept me stuck. Stuck in making everyone happy and ignoring my own needs and desires.

How to Get Nothing Done.

Criticize Yourself.

Imagine I show up to our next painting class to get help. I show my mess to Shanna and ask for help. Her eyes fell to the canvas, as she reacts in horror. She begins to laugh and mock me saying *"You thought you could fix this? This is not fixable. You are so stupid. How could you have messed this up? Why weren't you paying attention? How did you put so much purple in the wrong place? Just throw it away. You've ruined it."*

Confronted with the above imagined scenario, I would have thrown away my painting in embarrassment and failure. And never painted again.

Treat Yourself Unkindly.

It's a no brainer. However, we treat ourselves like this all of the time. Quietly reminding ourselves how we failed, how we should have done better, and how embarrassed we should be. It feels shocking. It sounds cruel. But it's how we treat ourselves and then justify such treatment by calling it the truth.

Below are some ways to increase your self-compassion.
- Observing yourself without judgment.
- Comforting yourself by taking a walk, a gentle touch, eating something nutritious, giving yourself a hug, etc.
- Speaking to yourself like you would a friend.

We gain confidence when we can trust ourselves to be safe.

Don't Ask for Help.

Shanna treated me with compassion, the night I called her in a panic. She assured me the painting could be fixed and encouraged me to bring it to our next class. I put my brushes away and went to bed agonizing over the mess I had made.

I showed up at our next session, disaster in hand, prepared to have it declared irreparable. However, she took my painting and worked her magic.

She lightened the stain, taught me what to do next time, and reminded me to always **stand back and squint**.

Beat Yourself Up.

According to research, being self-compassionate is to direct the same type of kindness, care, and compassion toward yourself that you would convey toward a friend who was suffering.

We think pointing out our flaws and weaknesses makes us try harder and keeps us from making mistakes. However, multiple studies show that self-compassion gets far better results than berating oneself.

When we beat ourselves up, we shut down, lose motivation, anxiety and depression increases, and self-worth declines.

Self-compassion is key to overcoming adversity, motivates us to keep trying, and boosts happiness. Having self-compassion also radically improves mental, physical, and psychological health. There are no drawbacks to being kind to yourself.

Many of us habitually treat ourselves harshly. and justify such treatment by calling it the truth.

Cindy Bayles

Allow Yourself to Suffer.

Self-compassion is being moved to relieve your own suffering, being caring and kind toward yourself, and having a nonjudgmental attitude toward your inadequacies and failures. How long would a quality relationship last if we continually pointed out each other's failures?

When we know we have our own back, we gain confidence in doing hard things. We are proud of what we have overcome, celebrate our failures and successes, and understand pain, regret, and hardship are part of life.

Ask yourself these questions:

What has not gone how I planned?

What did I handle poorly?

What was really hard?

Where have you failed?

What have you overcome?

I see your pain.
I love you for you.
I am here for you.

Self-compassion is being true to who we are, validating our pain, and letting ourselves know we are not alone.

Cindy Bayles

What is Self-Compassion

Three Parts of Self-Compassion.

Self-compassion is being true to who we are, validating our pain, and letting ourselves know we are not alone.
Self-compassion has three parts:

· **Self-kindness** – Being kind to ourselves, by using kind, gentle words when speaking to ourselves.
· **Common humanity** – Recognizing our own humanity and that everyone is imperfect and experiences pain.
· **Mindfulness** – Observing our negative emotions without focusing on them or suppressing them.

Observe Failure with Compassion.

Wanting these changes not because we're inadequate, but because we want ourselves to be happy.

When we have *self-compassion* **we stop beating ourselves up, giving up when things get hard, and ignoring our humanness.**

Cindy Bayles

The research is clear. What we say to ourselves matters!

Self-compassion is both self-acceptance and self-improvement.

When we have self-compassion, we stop beating ourselves up, giving up when things get hard, and ignoring our humanness.

You Are a Human.

When we understand our humanness, we gain a deeper appreciation for ourselves. In our struggles, failures, and hardships, we see the courage that it took to go on. But we also see the successes, joys, triumphs, and grit it took to get there.

We realize we are all doing the best we can. That we all suffer loss, sadness, and trials. But together we can grow stronger.

Everyone has a life that is 50% good and 50% bad. No one has a life that is 100% perfect, even if it appears that way!

No one's life is perfect, even if it appears that way!

Cindy Bayles

Be Your Own Best Friend.

What would it mean to you to be kind and gentle with yourself? To break the habit of reminding yourself what a failure you are? We are all guilty at one time or another of beating ourselves up.

You can Be Your Own Best Friend. You can be there when you are sad, lonely, happy, excited, or need a shoulder to cry on.

You can start creating that relationship today. You hold the power to create the relationship that you long for. A relationship that will last a lifetime.

It's time to stop beating yourself up and start cheering yourself on!

Practice Mindfulness.

Mindfulness connects you to your thoughts and emotions. Allowing you to decide what you think, how you feel, and what you choose. Thus, embracing your humanness. Mindfulness is the key to self-compassion.

It was tough to observe my thoughts and feelings, without judgment. Before being aware of my thoughts, I believed I had no control over my emotions.

When I became an observer of my thoughts and emotions, I gained insight into why I had certain thoughts and feelings. I realized I could decide what I thought, felt, and chose. This allowed me to mindfully choose my thoughts. And by choosing my thoughts, I was able to choose how I felt and take actions that better served me.

> **Mindfulness connects you to your thoughts and emotions. Allowing you to decide what you think, how you feel, and what you choose.**
>
> *Cindy Bayles*

Choose Who You Love.
Quality Thoughts = Quality Relationships.

Our thoughts are just sentences in our minds. Sentences that dictate how we feel and act. Though we may believe thoughts are facts. Thoughts are not facts.

Relationships are also determined by our thoughts. Which means, we get to choose who we like, hate, and love!

Let me say that again. **We get to choose who we love**. Because we get to choose who we love, we get to choose to love our past selves, our present selves, and our future selves. *No fixing required.*

When we practice quality **self-compassion**, we create quality relationships with ourselves. And what we think about ourselves determines how we show up for ourselves.

I love and accept my past, present and future, self.

Because we choose who we love, we can choose to love our past selves, our present selves, and our future selves.

Cindy Bayles

Present Me · Past Me

Compassionate Self-Talk.

We carry with us the words of our parents, teachers, siblings, and society. We have been told who we are and who we should be. We believe every word that was said. Good or bad. Positive self-talk can drown out those voices that hold us back.

As I practiced compassionate self-talk, my world started changing. I quit berating myself when I didn't measure up. I accepted myself as human. I courageously stepped outside of my comfort zone. I learned from my failures and reveled in my victories.

Stepping outside of my comfort zone is both exhilarating and terrifying. Exactly what life is meant to be.

Alleviate Your Own Suffering.

Self-compassion is to care about the alleviation of our own suffering. We have been socialized to believe that trying to alleviate our own suffering is selfish. This is simply not true. The truth is we are the only ones who can help ourselves.

We get to choose how we show up for ourselves. When we show up for ourselves with love and compassion, something happens on the inside. We stop looking for love and acceptance from outside of ourselves. It is no longer a limited commodity but generously offered from within our own hearts.

> **You have a front row seat to your needs, wants, and desires.**
> **You are the perfect person to** heal your heart.
>
> Cindy Bayles

Be Generous with Yourself.

When was the last time you were friendly, generous, and considerate of yourself? For me it was never. I was unkind to myself when I looked in the mirror, pointing out my flaws, and ignoring what made me great.

I had neglected my relationship with myself so much that I didn't have one. I thought it was other people's job to soothe me, to love me, to nurture me. But no one had the tools. I was the one that held the key to my needs, wants, and desires. It was my responsibility all along. It was never anyone else's job.

> I know just what I need!
>
> **I hold the *keys* to my needs, wants, and desires. It was my responsibility all along.**
>
> *Cindy Bayles*

Treat Yourself Like a Friend.

It takes work to create a close relationship. If your relationship with yourself could use some work, I have a few tips for you. You can create a relationship full of trust, love, and generosity.

Show up for yourself like a friend. Talk to yourself like a friend. Listen to yourself like a friend. Give to yourself like a friend. Ask yourself what you need and be generous with fulfilling those needs.

Put your hands on your heart and say, "I love and accept you." while inhaling and then repeating it again on the exhale. This is one of my favorite ways to love myself.

I love and accept you just the way you are.

Cindy Bayles

Standing Back and Squint

Standing Back and Squint at the Past.

25 years later, I searched my painting for the stain. It had been years since I had really looked at my painting. So, I saw my painting as if I were standing back and squinting.

But I couldn't find the purple stain anymore. I knew purple stains don't magically disappear. So, I searched my memory for where on the canvas the mistake was made. My eyes scanned every inch of the canvas. And you know what? The stain was still there. It didn't magically heal itself. It's part of the painting now. It's just an interesting purple shadow adding depth and character to the piece.

Stand Back and Squint at Your Humanness.

Standing back and squinting is an important skill. It gives us objectivity. The objectivity to see ourselves as human. When we stand back, we put distance between us and the trigger. We become observers instead of reactors.

When we squint, the glaring details fade. And we honor each other as fallible, imperfect, struggling, humans.

Give yourself grace.

When we use this tool, we have grace. Grace for your weaknesses, for your frailties, and for your struggles. Stand back and squint at the whole picture. The picture that God sees. The one where God loves us right where we are at.

> Give yourself *grace*. **Stand back and squint at the entire picture. The picture that God sees. The one where God loves you right where you are.**
>
> *Cindy Bayles*

Stand Back and Squint at Your Struggles.

When I **stand back and squint**, I am reminded that I am doing the best that I can. That we are all half good and half struggling.
What I have **overcome** makes me stronger.
What I have **overcome** made me who I am.
What I have **overcome** taught me valuable lessons.

I am beautiful, worthy, and acceptable just as I am.
Life can feel hard. We can be left with scrapes, bruises, rips, and tears. Those injuries do not make me any less of a person. Hard things make us resilient, strong, and brave.

Stand Back and Squint at Yourself.

We can be the hardest on ourselves. Picking apart every mistake, sin, or weakness. Branding ourselves with the purple stain of never good enough. **Stand back and squint**. Take a look at the doodle of you. Can you see the beauty, the strength, and the power there? That's you.

Standing back and squinting at myself allows me to see myself with compassion. To squint at myself living this life completely untrained. Someone who was trained by untrained humans. We ARE all doing the best we can. Sometimes the best we can looks like a deep purple stain that adds depth and character.

Stand Back and Squint.

Most will never notice my painting mishap. They will just see my painting as a whole. My brain thinks I need to hide my mistakes. So, no one should see my mess ups.

Many times, we decide our mistakes mean we are ruined. Dragging them into our future instead of leaving them in the past.

Maybe, our purple stains are just evidence of a life well lived. Evidence that it's ok to make mistakes. It's ok to stumble. It's ok to treat ourselves with love, kindness, and compassion. In fact, it's mandatory for survival.

> *What do you need?*
>
> **Ask yourself what you need and be *generous* with fulfilling those needs.**
>
> *Cindy Bayles*

Stand back and squint and start seeing yourself for the beautiful human that you are.

Doodle Activity

Stand Back and Squint Doodle.

Doodle along with me as we "stand back and squint" at ourselves. When we "stand back and squint", we can start seeing ourselves as worthy, whole, and loved just as we are.

Supply List:

- 1 Mixed media paper or cardstock paper.
- Watercolors.
- Pencil.
- Waterproof fine tipped marker.

1. Doodle you in the middle of your page.
2. Doodle your hands on your heart.
3. Doodle a dotted line down the middle of Doodle You.
4. On the left side, doodle the things that have been hard in your life. I.E. Relationships, health issues, perceived failure, abuse, loss, pain, baggage.
5. Doodle some scrapes, scuffs, and bandages on the left-side of Doodle You.
6. Doodle your successes, wins, gifts, and joyful moments on the right-hand side.
7. Above Doodle You write, I love and accept all of me!
8. At the bottom write the emotion you have when you look at your Doodle You. (Mine is compassion.)
9. Journal Prompt: How have these events created a beautiful masterpiece?
10. Journal Prompt: Do we love others despite their imperfections or because of them?
11. Go deeper. Add color with watercolor, crayons, markers, etc.
12. Stand back and squint at the amazing masterpiece of you!

Stand Back and Squint Doodle.

This is an unfinished Doodle Love. You can use it as a guide, finish it, and color it.

To access the free Doodle Therapy Workbook, go here: *https://doodletherapy.groovepages.com/book-free* or use this QR code. In the workbook you will find a place to answer the journal prompts and ideas of how to complete the Stand Back and Squint doodle.

3
Doodle Joy

"The root of joy is gratefulness. It is not joy that makes us grateful;
it is gratitude that makes us joyful.
Look closely and you will find that people are happy because they are grateful."

~ David Steindl-Rast

The Cave.
Morning Prep.

One Thanksgiving morning, my mother-in-law arose long before the sun. She had Thanksgiving dinner to prepare. With no time to waste, she jumped into her holiday preparations.

However, as the morning progressed, she became nauseous, developed a headache, and her vision blurred.

As a diabetic, she was concerned. So, she tested her blood sugar. But her blood sugar levels were normal, so she continued working.

As the sun peeked over the horizon, she couldn't go on anymore. So, she decided to head back to bed.

Sacred Spaces.

I too have crawled back into bed, too physically, mentally, or emotionally spent to go on. We all have. It's a sacred space. A place where we are allowed the time to heal, breathe, rest, and recover.

When my husband asked for a divorce, it ripped my heart out. The safety of my bedroom provided a place for me to mourn the loss of my life as I knew it.

My bedroom is holy ground. A place where I began to heal my broken heart, grieve my losses, and gain courage to face another day.

We all need safe places in our lives.

Seeing Clearly.

As my mother-in-law headed back to bed, she was startled by her underwear-clad husband. He squinted at her for a long while. Then said, "Nadine, are you wearing my glasses?!"

She stared at him, removed the glasses, examined them, and then sheepishly handed him his glasses.

Her morning came into focus as they swapped glasses, had a good laugh, and saw the day more clearly.

The wrong glasses made my mother-in-law sick, confused, and ready to give up. Looking through the wrong lenses can do that to a person.

Joy Blindness.

I too have worn lenses that distorted my vision. Those negative lenses created **Joy Blindness**. A disease that is at an epidemic today.

Through those lenses, I saw darkness, scarcity, and hopelessness. Those lenses darkened relationships, created heartache, and blocked me from seeing my blessings.

Everywhere I looked I saw what was missing or needed improving. My house wasn't clean enough, my body wasn't skinny enough, and I wasn't good enough. I thought "Once (this or that) changes, then I will be happy."

Negative lenses create *Joy blindness* **A disease that is at an epidemic today.**

I need something better!

This needs to be fixed!

Satan's Head Fake

This is Satan's head fake. He distracts us with surface happiness. He touts quick fixes for how to get a better body, make more money, and have more time. As we are chasing after these false pleasures, we miss the simple moments of joy.

The spectacular sunset, the kindness of another, and the miracle of clean running water, just to name a few.

We pass through our lives while searching for joy. Joy is waiting for us to notice her, embrace her, and befriend her.

However, we must seek joy out.

> **We pass through our lives while searching for *joy*.**
>
> **Joy is waiting for us to notice her, embrace her, and befriend her.**
>
> *Cindy Bayles*

Cave Dwellers

Hiding in The Cave.

Our failures and struggles can make us feel worthless, useless, and broken. When we are hurt, our fight or flight response tells us to hide. So, we hide in our safe caves.

This is what happened to me. I became a cave dweller. A cave dweller hides in her comfort zone. Cozy, warm, and safe. Because there was no reason to leave.

No one was to be trusted. I cut myself off from friends, family, and church. My heart was too tender, too fragile, and too raw to risk being hurt.

Do You Hide Too?

Friend, are you hiding in your cave too? Afraid to let your beautiful light shine? Afraid to be seen with your bumps, bruises, scars, and pain? It feels easier to stay in our cave, safe from the judgments of the world. Easier, yes. Fulfilling no.

The longer I stayed in my cave the more lonely, selfish, hopeless, stunted, and stuck I became. The harder it was to contemplate leaving. I may have been unhappy, but I was also comfortable. Who needs happiness anyway? It turns out happiness is not just about how we feel.

Studies show happiness makes us healthier, more productive, and even nicer.

What keeps you stuck in your comfort zone?

- What if I do it wrong?
- I might get hurt!
- I might die!
- No one can be trusted!
- It's scary out there!
- I hate people.
- What if they judge me?
- I don't have anything to offer!
- It's not safe out there!

Loss of Hope

When wearing distorted lenses, our cave feels like the best option. A cave is a place where we don't have to contribute, be seen, or be brave. In short, we don't have to be uncomfortable.

This keeps us stuck. Our mantra is, "If it doesn't feel good, don't do it!" Nothing changes day in and day out. We just exist. We lose track of what we like to do, what we want out of life, and what is possible for us.

In order to grow, we need to leave our comfort zone.

Wishing for Something Better.

When using distorted glasses, we are rarely happy with our circumstances. We become frustrated because we don't have all that we want. We focus on what we don't have and forget what we do have.

This is a powerful principle. What we focus on grows. When we focus on what we don't have, we see what we lack. However, when we focus on what we have, we see how wealthy we are.

It's time to remove those distorted lenses so we can see the blessings around us.

Cutting Ourselves Off.

When we hide in our caves, we cut ourselves off from other people. We hide from a world full of horrible, stupid, rotten humans. It's so easy to go there when the news is being piped into our homes from millions of different sources. All telling us about the latest tragedy, heartache, or crime.

We start to believe there is no hope left in the world. No hope anyone is kind, loving, or helpful. We start to believe the world is an unsafe, scary, and cruel place to be.

Joy Seekers

What Do You Love?

During marriage counseling, our therapist suggested I read a book titled *"The Divorce Remedy"*. My takeaway from that book? Go out and enjoy your life. Really that's what I learned.

I didn't know what that meant. I had been so focused on being a wife and mother that I had forgotten who I was.

So, I started small. I tried doing things just to see how they felt. Some things I loved, some not so much.

I filled my days with what I wanted to do. I went to football games, re-enrolled in college, got a job helping women, and rediscovered painting.

Live In the Moment

I realized that joy was all around me, I just hadn't noticed it. I had been looking for the next thing. For the kids to go to school, for the house to be clean, to have enough money to travel, and for my body to look like it did when I was 20. (Sigh)

Life is not meant to be hoped and wished away. It is meant to be lived to its fullest.

I won't say this time wasn't crushingly hard. It was. However, it was also a time of waking up to the beautiful life that I had been blind to. These simple changes created a joy-filled life that has been worth the effort.

Paint A Picture.

All it took was to change my lenses. My life went from drab and dull, to full and colorful. I looked at my life and my heart painted a picture. A masterpiece full of joy. It turns out we have the power to paint our own masterpiece.

We can paint a life of joy, love, and hope or we can paint a life of despair, lack, and darkness. It all depends on what filter we are using to look at our life.

The Joy of Serving.

My therapist suggested that I do some service while my marriage was falling apart. I know, can you imagine? Doing service was inconceivable to me. I have done a lot of service in my life, but this was not the time!

In his defense, studies show that serving makes us happier, live longer, and improves our sense of purpose.

Ironically, I did incorporate service into my life when I was hired to help families in crisis.

I was given the privilege of walking shoulder to shoulder with some of the greatest women I have ever known. As I worked with them, my heartache lifted, and I experienced glimpses of pure joy.

More than enough.

As I continued focusing on the light in my darkness, my world began to brighten.

I noticed blessings I had ignored before. I noticed my strengths when I had previously focused on my weaknesses. I noticed God's love for me, instead of cursing our circumstances. I began to create joy on purpose.

I became a **Joy Seeker**.

Joy seekers search for God's gifts.

A joy seeker doesn't ignore the bad, unhappy, and hard.

Rather, a joy seeker searches for joy, for light, and for truth.

> A *joy seeker* doesn't ignore the bad, unhappy, and hard. Rather, a *joy seeker* searches for *joy*, for *light*, and for *truth*.
>
> — Cindy Bayles

What is a Joy Seeker?

There is a simple formula to become a **Joy Seeker**. This formula requires intentionality. A Seeker practices gratitude daily, tries new things, and finds others to share their joy.

Seekers of Joy don't wait for joy to come to them. They seek joy in the tiny moments of their lives. Seekers look for opportunities to be grateful.

They try new things. They know life comes with pain and sorrow but are willing to forge ahead because life is meant to be lived and savored.

Seekers are powerful because they don't wait for joy. Seekers search for joy. Seekers look for opportunities to create happiness for others and joy in their own circumstances.

Gratitude Is A Superpower.

One of the attributes of a seeker is gratitude. Gratitude has been scientifically shown to improve:

Relationships

Physical health

Psychological health

Empathy

Sleep

Self-esteem

Mental strength

I don't know about you, but I need all of those!

But wait there's more!

The participants of a gratitude study were asked to record three things they were grateful for every day. These participants were 25% happier at the 1-month, 3-month, and 6-month checkpoints. Daily gratitude practice creates a gratitude habit. This new habit hones our attention towards gratitude, and we then feel happier.

Step Out of Your Comfort Zone.

Seekers step outside of their comfort zones and try something new. They know there are so many things to be experienced in this world and they are ready to try them all! (Well, most of them.)

They are done with hiding in a cave to keep themselves safe and are looking for the next great life adventure. Experiences where they can learn about themselves, grow into the women or men they are meant to be, and show up as their true selves.

Comfort zones are comfortable, but they don't require growth.

Comfort zones lack the vibrancy and excitement of creating one's own joyful moments.

Comfort zones lack the vibrancy and excitement of creating our own *joyful* moments.

Create Your Own Joy.

Joy doesn't just show up on our doorstep because we wish it so. We are the creators of our world. We can create joy, or we can create heartache. We get to choose our life experience.

One of the funnest and easiest ways to create joy is to do something out of the ordinary for you.

Do you want to learn something new or restart something?

Do you want to travel the world or grow a garden? The choices are endless. Staying in the same place will never produce different results.

You can feel joy today. Step out of your comfort zone and try something new!

Make Connections.

A BYU study found that social isolation is twice as harmful as obesity to physical and mental health.

Cindy Bayles

That something new can be something as small as calling a friend you haven't talked to in a while. Texting someone to see how they are doing. Smiling at the cashier at the grocery store.

Our cave keeps us from interacting with other people. Which in turn keeps us stuck in our cave. It can feel scary to interact with other humans who are full of emotions just like us.

It has been scientifically proven that interacting with others is imperative for mental health. A study at BYU found that social isolation is twice as harmful as obesity to physical and mental health.

Become a Joy Seeker
Start today!

Becoming a joy seeker is simple but not easy. Our brains are wired for negativity. So, we will have to train our brains to look for joy. The changes are not huge but are significant.

One of my favorite tools is the weekly habit tracker. You can find it in the Doodle Healing Workbook at this link.

https://doodletherapy.groovepages.com/book-free

This tracker will help you track your progress. As you track each habit, it will become a part of your daily life. Once the habit becomes engrained in you, you do it without thinking.
Go download it and let's get started!

Gratitude Journal.

Habit one: Create a daily gratitude practice. There are 2 parts. The first part is to write down three things that you are grateful for. There is a space on the habit tracker or use a journal.) Take the time to gaze at a beautiful sunset, notice a bug on the road, and look up at the stars hanging in the night sky.

Not hard. Right?

This second part is powerful. Take a few seconds and create the feeling of gratitude in your body. Put your hands on your heart and think about how grateful you are.

Let gratitude soak into your bones.

> **Journal Your** *Gratitude.*
>
> **Record three things you are** *grateful* **for everyday.**

Do Something Different.

Habit two: Get outside of your comfort zone. It's time to shake things up a bit. Do something different than you usually do. Try something new.

Walk somewhere new.

Eat something new.

Call a friend you haven't talked to for a while.

Paint without worrying about the outcome.

What could you do today that would bring you a spark of joy? Go and do that! No, don't stop to fold the laundry! Go!

Do the things that brings you joy!

Life is too short to live alone in our caves. Break out and do something new.

> **Simple Ideas to spread joy.**
>
> *How can I serve someone today?*
>
> Give a compliment.
> Let someone cut in front of you in line.
> Send an encouraging note.
> Smile and say hello.

Serving and Laughing.

Habit three: Find someone to serve. This is not as hard as it seems. Simply think about how you will connect with another soul today. Some easy suggestions are:
- Smile at someone.
- Say hello to someone.
- Say thank you.
- Send a text or email.

Habit four: Look for reasons to laugh.
Find a joke and tell it to someone.
Laugh together over shared memories.
Watch a comedy.

It is said that children laugh 300 times a day compared to adults who laugh only 4 times. This will quickly turn up your joy meter. Add it to your tracker and see what happens.

A simple exercise to start laughing.

1. Say Ha-Ha
2. Then Ha-Ha twice.
3. Continue adding a Ha-Ha until you are saying Ha-Ha 10 times.
4. Bet you can't make it to 10 without laughing outright!

Powerful Practice.

These four habits have been scientifically proven to create happier and more joyful people! I know! How can something so easy make such a huge difference? We are wired that way. It is time to take your happiness and joy into your control.

Start with just one of these habits. Notice any changes after a week or so. Then while still practicing the first habit, move on to the next. Soon you will have incorporated all four habits into your life. Your life will never be the same again.

You are a seeker of joy.

Doodle Activity
Leaving The Cave Doodle.

Doodle along with me as we doodle the Leaving the cave doodle. We will look at the things that bring us joy and the voices that keep us stuck and hiding in our caves.

Supply List:
- 1 Mixed media paper or cardstock paper.
- Watercolors, crayons, markers, etc.
- Pencil.
- Waterproof fine tipped marker.

1. Place a 8 x 11 piece of paper horizontally in front of you.
2. Draw a cave with eyes peering out of it.
3. Doodle flowers outside of the cave.
4. On the cave, write the thoughts that tell you to hide.
5. Doodle a Sun Shining out of the corner of the page.
6. Doodle life outside of the cave waiting for you.
7. Doodle You on the cave.
8. Doodle people next to you on the cave.
9. Journal Prompt: What are you grateful for?
10. Journal Prompt: What is something you want to try?
11. Journal Prompt: How can you serve someone?
12. Journal Prompt: What makes you laugh?
13. Start painting and adding color. Doodling creates mindfulness.

Leaving the Cave Doodle.

This is an unfinished Doodle Joy doodle. You can use it as a guide, finish it and/or color it.

To access the free Doodle Therapy Workbook, go here:
https://doodletherapy.groovepages.com/book-free or use the QR code.
When you download the workbook you will get the habit tracker, additional doodle instructions, and journal prompts.

4
Doodle Hope

"Some people go through life trying to find out what the world holds for them only to find out too late that it's what they bring to the world that really counts."

~ Lucy Maud Montgomery

Finding North.

As I was shoved into uncharted territory, my soul screamed, "I don't want to be here." "It's dark, scary, and unimaginable here!" "Which way do I go?" "What do I do next?" "This is not what I signed up for!!" "It's not fair! Why me!?!?"

I searched for something to guide me. I couldn't find the light in my darkness. "What should I do?" I asked myself. I heard nothing but silence.

As I was turning 50, I was lost, without purpose, direction, or any idea who I wanted to be in my life.

I had never thought about who I wanted to be. When we don't know who we are striving to be, there's no light. We need light to show us the way.

The North Star.

As a teen, I attended girls camp in the summers. We were certified in hiking, fire building, and first aid. One night we were taught how to navigate by the stars. At midnight, we gazed up at a canopy of stars and practiced finding the North star. It was magical.

I was taught that if I could find the North Star, I could find my way home.

Hmmmm. Really? That didn't sound correct to me. I had no idea how finding the North Star could help me if I were lost. Hear me out on this.

The conversation with the counselor went something like this:

Conversation.

Me: How does finding the North Star get me to where I need to go?

Counselor: It shows you which way to go.

Me: How?

Counselor: It points to North.

Me: Is home North?

Counselor: No. Not always.

Me: Then how does finding North get me home?

Counselor: You need to know which way home is.

Me: I don't understand. I thought I was lost.

For this directionally dysfunctional chick. I just didn't get it.

The North Star is…

Although there are billions of stars in the universe, when we need direction, the North Star is THE STAR. It sits precisely above the North Pole and marks the point around which the whole sky rotates. Pretty cool. Right?

The North star is always there. However, it may not always be visible. Trees, buildings, clouds, and even the sun may block the star from our view.

Knowing how to find the North Star is interesting. But it isn't helpful if we don't know where we want to go.

Without a destination in mind, we end up wandering in the wilderness.

Who Will You Be?

> Maybe there is no purpose to find.
>
> Maybe it's not about 'finding' my purpose.
>
> Maybe it's about deciding who I will be.
>
> *Cindy Bayles*

The same holds true with our lives. If we don't know who we want to be, we don't know how to become her.

As I was turning 50, I was without direction or idea of who I wanted to be in my life.

I had heard that I needed to "find my purpose". But I had no idea what my purpose was or how to "find" it. I took the tests and read the books but ended up more confused than ever.

I had no idea if I even had a purpose.

Who is Your North Star?

> **Choosing who I would show up as was like choosing a *light* to guide me.**
> — Cindy Bayles

Choosing who I would be was like choosing a light to guide me. A light my life revolved around. A light that guided my decisions, formed my goals, created meaning, and directed my life.

The purpose I needed was to become the future self I dreamed of. When we don't know who we strive to be, there's no light. There is only confusion.

To figure out who I wanted to become, I asked myself: Who do I want to be in 1 year? 3 years? 5 years? 10 years? Where can I make a difference?

Who would I be if I wasn't afraid of what people thought?

What's my Purpose.

Exploring.

Viktor Frankl, a holocaust survivor, who also lost his wife, parents, and many friends, in the Nazi concentration camps, wrote that circumstances are not what makes life unbearable. Instead, he says that **lack of purpose** is what makes life unbearable.

In Dr. Frankl's book, *"Man's Search for Happiness"* he uses examples of fellow prisoners who lost hope and died. Those prisoners hung their hopes on outside circumstances to change, such as being released by Christmas. When what they hoped for was crushed, many gave up and died.

Who Will You Be?

As I pivoted in my life, I knew who I didn't want to be. The trauma, chaos, and bitterness around my parents' divorce was stamped on my heart. That was not who I wanted to be. So, I changed my focus. Instead of worrying about who was wrong and who was right in my marriage, I focused on who I wanted to be.

Little by little, I started doing things differently. I incorporated more of what I WANTED to do and did less of what I felt obligated to do. From there, I caught a glimpse of a whole new life.

Hopes and Dreams.

So many of us carry hopes and dreams we've longed to embrace. Yet, as these aspirations emerge, we swiftly suppress them. We convince ourselves that wanting these dreams is selfish, a mere fantasy, a futile pursuit of time, or that it's simply too late. These are, in essence, excuses. I understand because I've been there, just like you.

We've invested too much time in telling ourselves what we can't attain or wish for. But here's the truth, my friend: hope is still very much alive. You can achieve, become, and possess anything you yearn for. The catch? You must be willing to pay the price.

> *Hope* is not lost my friend. You can be, do, and have, anything you desire.
> — Cindy Bayles

Pay the Price.

The price is steep. Many are not willing to pay the price.

The cost to realize our hopes and dreams is the willingness to change what we believe about ourselves.

Taking a close look at our beliefs about who we are is crucial. To evolve into a version of ourselves that's different, we have to be honest with ourselves. The self-deception happens when we buy into the idea of our inadequacy, compare our journey to others, and convince ourselves that it's too late for personal growth.

Plant a new belief. A belief that you are amazing and have something beautiful to offer the world. Because that is exactly who you are. Never forget it!

> Plant a *belief* that you are *amazing*. A *belief* that you have something beautiful to offer. Because you do. *never forget it!*
>
> Cindy Bayles

Be Your Future Self.

Honestly, my past self is unrecognizable to me. I have overcome things she never thought possible. All because I made a choice. A choice to decide who I was going to be.

I work like hell to become who I am meant to be. I am the person who decides who I am today, tomorrow, and 10 years from now. Living my purpose has changed how I interact with my life on all levels. Falling down and getting back up is part of the process.

Your Guiding Light

Purpose Gives Us Focus.

One of the benefits of choosing a life of purpose is it gives us focus. When we have focus, we know exactly where we are headed.

The British rowing team hadn't won gold since 1912. They wanted to become Olympic champions. In anticipation of the 2000 Sydney Olympics, they decided to ask themselves one question each time they were confronted with a decision.

That question was, "Will this make the boat go faster?"
Eat a donut? "Will this make the boat go faster?"
Practice longer? "Will this make the boat go faster?"
Drink on the weekend? "Will this make the boat go faster?"

This simple question was the catalyst that took a failing team from average to gold, breaking a 78-year losing streak.

Purpose is Good for You.

According to a study published in 2016, having a purpose may decrease our risk of dying early.

Researchers analyzed data from nearly 7,000 Americans between the ages of 51 and 61. Half were women.

2X — **People without a strong life purpose, meaning "a self-organizing life aim that stimulates goals," were TWICE as likely to die of cardiovascular diseases.**

Cindy Bayles

The findings of this study were surprising. People who didn't have a strong life purpose, meaning "a self-organizing life aim that stimulates goals," were twice as likely to die of cardiovascular diseases. The association between a low level of life purpose and death stayed true despite how rich or poor participants were, and regardless of gender, race, or education level.

Miracle of Purpose.

Miracles happen when we live our purpose. God puts people in our path and creates circumstances that we could never have created on our own. The planets align and things happen that can only be explained by God's hand.

Because living our purpose stretches us, we must rely on God to reach our goals. We are strengthened as we do things that we never thought possible. We fall down and get back up. To quit our purpose is not an option and failure is just a steppingstone in our journey to our purposeful life.

A Purposeful Parable.

A parable by an Italian psychiatrist tells the story of three stonecutters building a cathedral.

When the first stonecutter is asked what he is doing, he replies with frustration. "I cut the blocks exactly the same way over and over again until the day I die."

The second stonecutter, however, replies with love. "I am earning a living for my family whom I love very much."

The last stonecutter responds with a joyous voice as he explains, "It is a privilege to participate in building this great cathedral that will stand for thousands of years."

Live for Something.

The pursuit of purpose enhances our lives in every way. When we have a purpose, we are excited to get out of bed, have a vision of our future, and a plan that will change our world. Having a purpose keeps us moving because we see the benefit of our work. Fast tracking our road to joy.

Winston S. Churchill said, "It's not enough to have lived. We should be determined to live for something."

But what if you know who you want to be, but you are stuck? How eactly do you become that person?

Getting Unstuck

Fear of Failure.

Fear keeps us stuck. Believe it or not, fear and our brains' response to it has blessed our lives by keeping us alive. The problem comes because fear is our brain's natural response to danger. When we perceive danger, our brain kicks into survival mode.

We are hardwired with 4 responses: fight, flight, freeze, or fawn. Our Amygdala releases the survival hormones, and we react without thinking. We fight back, run away from danger, are frozen in place, or consent and try to please.

il was always annoyed by this because I was not acting how I wanted to react.

What Other People Think.

The fear of what other people think keeps us hiding in our cave. When we put other people's opinions above our own, we hide in our comfort zone. Inside of our comfort zones, we hide our gifts, dim our light, and quiet our voice. We call this being stuck.

It takes courage to put aside people's opinions.
It takes faith to let God lead.
It takes hope to take steps toward our purpose.
Your comfort zone is blocking your light, my friend.

Stepping outside of your comfort zone is uncomfortable. But when you get uncomfortable you show others the way out.

> **Your comfort zone is blocking your** *light*
> **It might feel uncomfortable to let your** *light* **shine. But by getting uncomfortable, you** *light* **the way.**
>
> Cindy Bayles

Comparison = Pride

Pride shows up when we compare ourselves to other people. It can be from the bottom looking up or from the top looking down. When we compare ourselves by looking up at other's accomplishments, we never win. We feel less than and shrink to avoid being seen or judged.

However, there is another sort of comparison. That compares from the top looking down. This kind of pride is finding ways we are better than another person.

Comparison keeps us stuck. We are either frozen in fear of being seen and judged or we are not teachable when measuring our worth better than someone else.

You Are a Masterpiece.

Every person is unique. We each have our own experiences, tragedies, and talents. Because of our differences we have different perspectives to offer.

You have a masterpiece inside of you, waiting for you to create it. A masterpiece that only you can create. If you die without sharing your gift with the world, no one will ever see or benefit from your light.

Your masterpiece will be completely different from anyone else's and that is a beautiful thing.

The only thing that matters is what you and God think.

You have the power to tear down the walls of your prison and set yourself free to shine.

Baby Steps.

So how do you create your masterpiece? Where do you even start?

We often get hung up on the big picture. You know the one. That masterpiece I just referred to. I mean how does one even tackle a masterpiece when they have never even doodled before?

They start. That's it. That's the answer.

Once we have defined our big, scary, future. We start intentionally moving toward our new future.

We learn what we don't know.

We practice a new skill.

We ask for help.

We try and fail and try again. Then we look back and see how far we have come.

Forward with Hope.

Who will you be?

One of the best questions that I have asked myself is "Who are you becoming?" This is not a question about whether I will be a doctor or a nurse. It is a question about how I will show up in the world. When we know who we strive to become, we know everything.

Make a list of the ways you do and don't want to show up.

> **Will this help me become my future self?**
> *Cindy Bayles*

This is our guiding light. The place that our whole world rotates around. And every decision is made. The question that we keep asking is "Will this help me become my future self?"

Everyone Has a Purpose.

As I began creating a new plan for myself, it felt like I was barely moving. I wanted more but it felt soooo hard.

Learning can feel hard. But like anything, with practice it gets easier.

You can make a difference in this world. It is not by chance that you live and breathe at this time, in this place. Every one of us is on this earth for God's glory and purpose. As long as you have breath in your body you have a purpose. Your bold action can change your world and the world.

> **It's not by chance that you *live* and *Breathe* at this time, and in this place.**
>
> *Cindy Bayles*

Make an Impact.

We don't make an impact on the world by playing small. We create change by showing up and doing the work God has sent us here to do.

Honestly, there is nothing standing in the way of becoming who we are meant to be except for what we believe.

It's simple really. We either believe it's possible or we don't. If we believe it's possible, we act. If we don't believe it's possible, we don't act.

Let's discard our beliefs about what we are not capable of and create new beliefs about who we are and who we are meant to be.

Set an Intention.

When we go about our days, with the intention of becoming greater, magic happens.

Practice is the key, my friend. Choose a guiding **word** for the year. A word that makes you reach higher.

Repeat this word daily and envision incorporating your **word** into your life. This will embed your **word** into your subconscious.

Little by little you begin to mimic the actions, thoughts, and feelings of your future self.

What miracles will you create?

Are you ready to change the world?

Changing the world starts with choosing who you will be and then becoming your word. Who will you be in a year from now?

> **When we go about our days, with the intention of becoming greater, magic happens.**
> —Cindy Bayles
>
> **HOPE**

Have you Felt the Nudges?

Have you felt the nudges from God? Are you ignoring God's whispers? You keep thinking you are not good enough or you don't have the experience someone else has.

God does not look for experienced people. He looks for people willing to do the work. People who might be a little rough around the edges. He calls people who are not speakers to speak, followers to lead, and sinners to call people to repentance. You don't have to know how to be what God needs. You need to answer His call. And when you answer His call **get ready for the ride of your life**!

Doodle Activity
North Star Doodle

Doodle along with me as we create a word of the year. This word doodle should inspire, encourage, and stretch you in the coming year.

Supply List:

- 1-5 x5 Mixed media paper or cardstock paper.
- Notebook paper.
- Watercolors, crayons, markers, etc.
- Pencil.
- Waterproof fine tipped marker.

1. Start with a 5 x 5 heavy weight piece of paper. In the workbook, brainstorm a list of words that reflect who you want to be.
2. Circle the one word you want to become this year. This is your North Star.
3. Doodle the word on your paper or print out the word and glue it on.
4. Write the definition of your word.
5. Journal how you will show up with this word as your guide.
 a. Take a deeper look. How will this word affect your relationships, time, job, etc.
 b. On the back write how it will feel to become your word.
6. Write the thoughts that empower you to become this word.
7. Paint your doodle.
8. Put it where you will see it every day.
9. Memorize your definition.
10. Give yourself Grace. Remember we are just learning.

North Star Doodle

THOUGHTS | **MY TIME**

HUNUR

CALENDAR | **FEELINGS** | **MY HEART**

This is an unfinished North Star doodle. Use it as a guide, finish it, and/or color it.

To access the free Doodle Therapy Workbook, go here: https://doodletherapy.groovepages.com/book-free or use the QR code. The workbook has a list of possible words, new thought choices. The finished North Star doodle, and room to journal.

Section 2
Doodle Your Mind

5 Doodle Boldly

"Freedom lies in being bold."

~Robert Frost

Princess Camping.

Dolores Triangle.

Several years ago, my husband and I went to the Dolores Triangle to go camping. It's like the Bermuda Triangle, but landlocked. It's beautiful but a pain to get to. The road into camp was sketchy, so we were sure to bring everything we might need. It would be impossible to drive out after dark.

I love camping but only when it's set up for the princess in me. Knowing that, Lyle pitched our tent, blew up the air mattress, laid out our sleeping bags, and built a fire. It was perfect!

Cuddling in the Woods.

As the sun set, the temperature began to drop, so we headed to bed. We thought it was perfect timing as we climbed into the freshly made bed.

Unfortunately, as the outside temperature plummeted, our bed grew cold as well. We were freezing. It didn't matter what we did, we couldn't get warm.

We stacked sleeping bags on top of us, plastered our bodies against each other, and got fully dressed including our coats. Nothing seemed to help! I was convinced that we were going to freeze to death in the middle of nowhere.

In desperation, I suggested a technique to treat hypothermia, I had seen in a movie.

Naked Camping.

This technique involves removing one's clothes and pressing each other's bodies together. Having nothing left to lose, we attempted naked camping.

We removed our clothes, pressed our naked bodies together, and held onto each other. We could only stand fifteen seconds before we hurriedly put our clothes back on. We were colder than ever! Hoping to survive the night, we redressed, adding coats to our attire. We lay fully clothed under a mound of sleeping bags trying to figure out why we couldn't get warm.

Then my husband had a ridiculous idea! He wanted to take a sleeping bag from on top of us and put it underneath us?!?

Sleeping on Air.

It sounded ridiculous. But I was willing to try anything. So, shivering and shaking, we crawled out from under the sleeping bags, took one from the pile, and laid it underneath us. Then jumped into bed.

And guess what? We started getting warm! So warm we had to remove a few sleeping bags from the pile. My mind was blown!

Apparently, the air in the air mattress reflects the temperature of the outside air. So, the thin blanket underneath us couldn't block the freezing air in the mattress. Which means that piling blankets on top of us was a magnificent waste of time.

We needed to build a solid foundation underneath us.

Solid Foundation.

When my husband asked for a divorce, I felt worthless. My worth had been based on my husband's love, my children's accomplishments, my church participation, my husband's success, and the size and shape of my body. In short, my worth was based on what other people thought about me.

My mood, like the temperature in an air mattress, depended on other people. Because I couldn't control other people's thoughts or actions, I was frequently defensive.

In the inadequacy triangle, we compare ourselves to others, focus on our flaws, and hide in our cave.

83

I lacked a solid foundation. Because I didn't have a solid foundation, I was always in the Inadequacy Triangle. (Don, don, don…) In the inadequacy triangle, we compare ourselves to others, focus on our flaws, and hide in our cave.

Foundationless.

Don't Take Action. (Remain frozen)

Many of us live in the inadequacy triangle.

A Hewlett Packard report found women apply for a job or promotion, if they meet 100% of the qualifications.

However, men apply for the same positions when they meet only 60% of those qualifications.

Even when women meet 100% of the requirements, we hesitate. Believing there is still need for improvement, so we don't try. This keeps us from making bold marks on our lives.

Instead, we make timid marks. Marks we throw away. Marks that no one sees. Marks that never make a difference.

Comparing Ourselves.

Sitting at the top of the inadequacy triangle is comparison. Theodore Roosevelt said, "Comparison is the thief of joy." When we compare, we undervalue ourselves, eat away at our foundation, disregard our strengths, and focus on our weaknesses.

Every single time I compare myself, I come out the loser. Recently, a woman I admire was comparing herself and wanted to quit.
I had been watching her progress. She was killing it! I was thinking how cute she was. How good her videos were. And what an excellent job she was doing.

And then I thought "You should give up. She is better than you." What???? There is no winning when comparing.

Look for Validation.

Do you know why I thought I should give up? Because I only saw my clumsiness on camera, my subpar doodles, and my awkwardness with people.

Were those things true? Or were they just my perceptions?

No one told me sucked. But no one said I was good either. We seek approval in order to feel better. It's like piling blankets on an air mattress. We can never get warm without a solid foundation. The strength of our foundation determines what we allow and disallow in our lives. We get to choose how we treat ourselves.

Frozen in Fear.

Lacking the foundation of knowing who I was, I had no idea what I needed. I couldn't see that I had anything to offer. I saw talent all around me; but I saw nothing of worth in myself.

This left me frozen in fear. I was afraid to try because I might feel the cold sting of someone's criticism or the despair of failing. So, I hid in my cave (my comfort zone) and clung to my mediocrity. Believing that nothing short of perfection was good enough.

Try to Fix Ourselves.

My solution was to "fix" myself. If I were "fixed" I would be worthy. So, I created a list of things I needed to overcome. You know the list. We have all had one.

Mine included:

Lose weight.

Be kinder.

Do more.

Make everyone happy.

Do even more.

Don't get cranky. I.E., don't have feelings.

This was what "good enough" list looked like.

That's the goal, isn't it? To fix what's wrong with us. So, we can be good enough and finally be happy.

It's crazy making! We expect ourselves not to be human!

Build your foundation on:

- Honor
- Trust
- Forgiveness
- Compassion

Solid foundations

Relationship with You.

Golda Meir, a teacher in Milwaukee, became Israel's first female prime minister in 1966. Golda saw beyond her possibilities. She encouraged us to trust ourselves, to fan our inner spark into flames of achievement and to become someone we look forward to living with.

What if we became our biggest cheerleader?

We have many relationships. But the relationship with our soul has been neglected for too long. We have let ourselves down at the expense of joy, peace, and sanity.

We create a strong relationship with ourselves by building a solid foundation. A foundation built on trust, compassion, honor, and forgiveness.

Create Your Future.

The past IS powerful. The same circumstances I beat myself up with, are the same ones I built a new foundation on.

When I remember what I have overcome. What thoughts and feelings got me moving and what I said to myself when I was frozen in fear. I gain power to change my trajectory.

Abraham Lincoln once said:
"The best way to predict the future is to create it."

> **The best way to predict the future is to create it.**
>
> *Abraham Lincoln*

My future depends on what I believe.

I am not my circumstances. My thoughts. My feelings. My actions. Or my results.

I am a girl building a solid foundation. A foundation built on yesterday's failures and today's triumphs.

Born Worthy.

Solid foundations equal knowing our worth.

We are born worthy. There is nothing to do to become worthy.

Babies don't become worthy when he/she:
Loses those chunky thighs.
Sleeps through the night.
Does more.
Walks.

Is less selfish.
Does even more.
Talks.
Feeds themselves.
Each baby is perfect just as they are.

We gaze at each baby in all their undoneness. We love them exactly as they are. With all the potential that is wrapped up in that tiny, baby body. Ready to grow and become what they were born to do.

One baby step at a time.

Solid Footings.

With solid footings, we are unstoppable. We shine boldly, bravely, and beautifully.

When we love ourselves first, everything begins to fall into place. If we don't love ourselves, we can't get anything done.

When we love ourselves, we are allowed to make mistakes, try new things, and become who we were meant to be.

We give ourselves the freedom to move forward without fear of repercussions. This is when our world changes. It turns out the person we long to please was inside of us all along. When we turn the power over to her, she gets things done!

Trust Ourselves.

As love seeps into our souls. We encourage ourselves to reach higher, dream bigger, and live bolder. We trust ourselves to know the way. This is who our soul longs for.

When what we think of ourselves is more important than what others think, we are free. Free to be who we were meant to be, free to stand up and speak up, and free to choose a better way.

When we change what we think, we change how we feel. When we feel differently, we act differently.

Loving and trusting ourselves is a heroic act of foundation building.

Building a Foundation.

Core Beliefs.

But how do you think differently when you know in your bones, you aren't good enough.

I couldn't just decide I had value. It wasn't that easy. How could I take that leap?

In order to feel good about myself, I tried solving for who I was. I tried self-love mantras and affirmations. I sought out other people's opinions of my worth. I accomplished things I thought would make me feel better. None of these worked. They couldn't override my core belief, that I was flawed beyond repair.

Foundational Shift.

The solution wasn't an overnight fix; It was a foundational shift. I needed a solid foundation.

A foundation built on love, trust, acceptance, and compassion. A foundation built to withstand life's storms.

A foundation deep enough to support my big dreams. A foundation built layer upon layer. Brick by brick. **Thought by thought.**

I dug deep. I created thoughts on purpose. Thoughts that I was worthy. Quality thoughts that became quality beliefs.

And bit by bit, I began to see my worth. Exactly as I was. No fixing required.

It's an ongoing process. This process will last a lifetime. It has been worth the struggle and then some.

Dig It Deep.

You can tell the height and strength of a building by its foundation. A deep foundation equals a strong & tall building.

I needed a deep foundation. A foundation built on my values, my beliefs, my hopes, and my dreams.

How does a girl dig a deep foundation?

She Intentionally digs deeply. She becomes a compassionate observer of herself.

She drops the should dos. Then she does what feels right to her.

She asks powerful questions.
What do I like?
What do I value?
What do I believe?
How do I want to live my life?
What do I hope for?
What are my dreams?

> **The higher the building, the deeper you must dig.**
>
> *Mongolian Proverb*

Trust Yourself.

The first layer I built was trust. After a lifetime of letting myself down, it took some work to turn the ship around. I had been at the bottom of my list for far too long.

It was easy to let myself down. Sometimes, I just don't wanna and I am the only one that would know. But when I don't show up, I show myself I don't matter.

So, I made dates with myself and honored them. I kept showing up trustworthy, dependable, and kind.

I treated myself with the love and respect I would give a queen.

Your Strengths.

As I focused on my strengths and embraced my gifts, I began to understand my worth. My answers were always inside of me. I began to stand boldly, speak from my heart, and be seen as I am. No matter the road I have trod, I am no better or worse than the next girl.

I can never reach my potential by hiding. Hiding is safe.
Hiding is comfortable. Hiding also keeps us from being seen, heard, and making an impact.

We gain strength when we boldly show up. No fixing required.

Foundation Building 101.

Build Your Foundation.

The most important part of a foundation is the base. If the base isn't rock solid, the building will not withstand turbulence. It doesn't matter how well the other layers are constructed.

Our base is built with **self-compassion**. It is about knowing that you can be trusted. Trusted to treat yourself with love and compassion. Allowing yourself the space to fail, make mistakes, and keep trying, treating yourself like your best friend, and reminding her you love her no matter what. **Self-compassion** is holy ground. Ground that needs the utmost care.

Use Maybe and Might.

With self-compassion as our foundation, we gain freedom to live boldly. But doing something outside of our comfort zone feels frightening!

At a rough time in my life, going to church was hard. So, I used modifying words to take the pressure off. Words such as: "Might", "maybe", and "it's possible".

I would say, "Maybe, I can go to church today." Then I would start getting ready for church.

Adding modifying words makes it easier to work toward a different future. You don't have to BE that right now. You can think about trying it on to see if it fits.

That's Just Like Me!

Getting ready for church was a tiny step for me. A step in the right direction. So, I used the phrase *"That's just like me!"* As I got ready. And if I didn't make it to church, I would say, *"That's not like me!"*

Most of us do this backwards. We use these phrases to prove our unworthiness. Such as, *"It's just like me to quit!"* and "That's just like me not to follow through! "

We gain momentum when we change the script. We change the script when we shout, ***"That's just like me!"*** every time we head in the right direction.

Failure as Fuel | Keep Going!

Inevitably you will say "That's not like me!"
Perfect! You're on the right path.
I used to think failure meant something about me. Failure is part of the process! We try. We stumble. We learn. We grow.

JK Rowling's Harry Potter was turned down twelve times before being published, Oprah Winfrey was fired as a news anchor, and Lucille Ball's first films failed miserably. Their failures fueled their success!

We can turn our failures into success too. By failing forward.
When we say, "That's not like me!" Ask yourself:
What worked?
What didn't work?
What can I do differently next time? Then try again. You've got this!

Boldly Doodle

It's time to speak your truth, draw attention to yourself, create change, and shine your light.
Getting outside of your comfort zone will do that to a person.
There is no time to waste. Our earthly time is limited.
What is your mission?
What tiny, consistent, steps will get you there?
Take a step and then take another step.

Bold strokes create masterpieces. Shine your light my friend!
Cindy Bayles

Live boldly as you:

Practice self-compassion.

Use modifying words.

Say "That's just like me!"

Use failure as fuel.

Say, "You've got this!" as you put on your crown.

Bold strokes create masterpieces.

Shine your light my friend!

Doodle Activity
Foundation Building Doodle

Doodle along with me as we create a foundation that will support you in boldly living your life. It's hard to be bold and courageous when we don't support ourselves. This is a powerful doodle to see how we can help ourselves live a bold and courageous life.

Supply List:

- 1 Mixed media paper or cardstock paper.
- Watercolors, crayons, markers, etc.
- Pencil.
- Waterproof fine tipped marker.

1. Doodle the top of the world at the bottom. (This is other people's opinions)
 a. Write "What other people think of me is none of my business."
 b. On the world write some opinions that hold you back.
2. Doodle your foundation base on top of the world.
 a. Write Self-Compassion here.
 b. How can give yourself more self-compassion.
3. Doodle the next tier of your foundation.
 a. What modifying words could you use?
 b. Such as I might, or maybe I can.
4. Doodle the third tier. How you can cheer yourself
 a. I use "That's just like me!"
5. Doodle the fourth tier. Write Failure is fuel.
 a. What failure can you use as fuel?
6. Doodle the final layer. Write "I've got this!" Doodle you on top of the pyramid with a crown on your head! You did it!
 a. What are you proud of?

Foundation Building Doodle

[Pyramid doodle with figure on top holding a flag, levels labeled from top to bottom: "I've got this!", "Failure is fuel", "That's Just Like Me!", "Modifying Words", "Self-Compassion"]

This is an unfinished Foundation Building doodle. You can use it as a guide, finish it, or color it.

To access the free Doodle Therapy Workbook, go here: *https://doodletherapy.groovepages.com/book-free* or use this QR code: In the workbook you can see the completed Foundation Building Doodle along with plenty of space to journal and create a strategy to build your own strong foundation.

6
Doodle ANTs

"Give careful thought to the paths for your feet and be steadfast in all your ways".

~Proverbs 4:26

Pain.
Hand Pain.

"Owwww", I screamed. The OT pointed to a pain chart showing faces in various degrees of distress. "What number was that?" he said. "8?" I whimpered. Then he bopped my wrist and repeated the question. This was not going well.

He moved his hand to my elbow and began massaging it. I was relieved. Maybe, I was getting an elbow massage! Pain shot up my elbow. "What number was that?" He asked. I had no clue. What number is it when you see stars?

Ignoring the Pain.

I had an OT appointment because my hands were getting stiff.

I imagined the appointment going something like this; my hands slathered with lotion, massaged, and placed between warm towels,

soft music playing in the background. It sounded heavenly. But there was NEVER a massage.

The therapist's abuse continued for 60 minutes!

I went to that appointment, blissfully unaware of the pain in my hands. When I left, I KNEW I was in pain.

Apparently, when pressure is applied to our nerves, there should be no discomfort. And by ignoring that pain, I was developing arthritis.

Pain Has a Purpose.

The cool thing about our bodies is that pain means our bodies are trying to get our attention. Pain makes us aware that something might be wrong.

Imagine if you touched a hot stove and didn't feel pain. A lot of damage would occur. Instead, our mind reflexively pulls our hand away.

> *Ouch! That hurts!*
>
> **Pain doesn't feel good, but pain is just trying to protect us.**
>
> *Cindy Bayles*

We still get burned. But we don't suffer catastrophic damage. Pain may not feel good, but it is there to protect us.

I decided that it was time to start paying attention to what my body had to say.

An Overnight Fix.

Many of us sleep like a fetus in the womb, our hands, and arms folded in. This causes our appendages to "fall asleep" from lack of blood flow. Resulting in irritated nerves.

I had no idea I had this habit. I was sleeping for heaven's sake. While sleeping, I irritated a nerve in my elbow and that nerve was contributing to arthritis in my hands. Weird right?

The prescription? Zombie-like devices of torture. Worn at night, they kept my arms from bending more than 60 degrees. As you can imagine, they are extremely sexy and comfortable to wear. (Insert Sarcasm here) But do you know what? The torture devices began to help.

Painful Thoughts.

I wondered what other habits I had that were causing me pain. At first, I couldn't find any bad habits. But our habits are hiding in plain sight. It just took a bit of detective work.

Many of my habits created pain. But the worst offenders were my thoughts!

It has been estimated that we have around 70,000 thoughts a day. 90% of those thoughts are repetitive and most are negative.

Dr. Daniel G. Amen, a psychiatrist, physician, and author, labeled this type of thinking Automatic Negative Thoughts or ANTs.

I had plenty of Automatic Negative Thoughts that kept me stuck and in emotional pain.

90% of repetitive thoughts are negative.

Cindy Bayles

Unintentional Thoughts
ANTs.

Everyone has Automatic Negative Thoughts. Our brain's operating system is infested with ANTs. Most of us believe our thoughts are true. And therefore, our Automatic Negative Thoughts are true.

But ANTs are not true. ANTs are distorted thinking. If they are left to run amok, they are dangerous to our mental health. ANT's create anxiety & depression.

Most of us believe our circumstances create our feelings. However, it's our thoughts ABOUT the circumstance that create our feelings. There is a distinct difference. We unknowingly create emotional and mental pain with our thoughts.

Effects of Negative Thinking.

According to a 2020 brain imaging study on Alzheimer's & Dementia, the way we think has a long-term effect on our mental health. ANTs may promote the buildup of harmful deposits seen in the brains of people with Alzheimer's and may increase the risk of dementia.

In an article in the *Journal of Alzheimer's Disease,* researchers found that prolonged ANTs reduce our brain's ability to think, reason, and form memories. And yet another study looked at the relationship between cynicism (the belief that others are selfish) and dementia, it found double the number of cynical participants developed dementia.

Thoughts = Feelings.

Thoughts signal the release of chemicals. Those chemicals affect every cell in our bodies.

Positive thoughts = positive feeling chemicals.

Negative thoughts = negative feeling chemicals.

Strong, negative emotions like anger, anxiety, and fear put our bodies into a heightened state of stress. This stressful feeling is meant to warn us of danger.

The problem is in our modern world, we live in relative safety. Not that long ago, humans were in danger of dying when leaving their

cave in search of food, water, or warmth. Our feelings of anxiety and fear are there to keep us safe.

What Pain are You Creating?

My husband was a police officer for 30 years. He began his career excited to help others and ended it angry and bitter. He lost trust in humankind, faith that people can change, and hope for a better world.

A police officer's job is by definition negative and stressful. The exact prescription for depression and anxiety. Over the years he created many ANTs.

When his career ended, he was on several anti-depression and anti-anxiety meds. But those drugs didn't help him feel better. Those drugs just took away his will to actually kill himself.

Negative thoughts steal our happiness, create pain, and make us angry. Most of our thoughts are infested with ANTs. There is a remedy to overcome our negative thoughts. That remedy is **radical honesty**.

To practice **radical honesty**, we need to become watchers of our thoughts. Meaning we don't believe everything we think. With **radical honesty**, we gain a different perspective on our thoughts and feelings.

I have found the following empowering questions help me find the whole truth.

- Is this thought 100% true?
- Could this thought be proven in a court of law?
- Does EVERYONE believe this thought?

> **Find Your ANTs By Asking These Empowering Questions**
>
> - Is this thought 100% true?
> - Could this thought be proven in a court of law?
> - Would EVERYONE believe this thought?
> - Does this thought help or hurt me?

Intentional Thinking.

Neural Pathways.

Our brains are built with powerful neural pathways. These pathways enable us to interact, create memories, learn, and experience emotions and sensations.

Neural pathways are born from thoughts. Every time we think the same thought, our neural pathways become stronger. As the pathways become stronger, they become beliefs or habits. *A belief is a thought that we think over and over again*.

Some beliefs are not true even if we have the evidence to back up that belief. That's what brains do. Our brains find evidence to prove our beliefs.

Once established the pathways in our brain are difficult to change. However, with some intentional practice, we can create new pathways.

> **Neural pathways are born from thoughts. Every time we think the same thought, its neural pathway becomes stronger.**
>
> *Cindy Bagley*

New Thoughts.

Positive automatic thoughts can offset the effects of both negative automatic thoughts and stress in general.

For example, people with frequent positive automatic thoughts are more likely to respond to stress by feeling that their lives are more meaningful, while people with infrequent positive automatic thoughts are likely to respond to stress by feeling that their lives are less meaningful (Boyraz & Lightsey, 2012).

These findings suggest that *any* form of positive thinking is better than allowing ANTs to take up residence in our minds.

This is not to say that all thoughts should be positive. There are things in life we want to be upset about. Such as the death of a loved one, injustice, etc.

We are Not Going There!

> **Positive thoughts can offset the effects of both negative thoughts and stress in general.**
> *Cindy Bayles*

This is powerful stuff. My husband, who had been battling anxiety and depression for over 20 years, blazed new trails in his mind! He described his anxiety and depression, when at its worst, as being in a pit. It was accompanied by the belief there was no way out.

He decided to take his healing into his own hands. When his ANTs show up, he says to himself, "I am not going there." He then redirects his thoughts.

It was rough for a long time. But as he continued to practice this powerful tool, his anxiety and depression began to lift.

Positive Changes.

Choosing positivity sounds cliche'. However, positive thoughts do more than make us feel better. Positivity restructures our brains.

Research shows that when we focus on positive words, it affects our brains. My favorite part is when we have a positive view of ourselves, it biases us toward being positive towards others. And when we have a negative view of ourselves, we are more likely to look at others with suspicion and doubt.

Ripples of Positivity.

This is mind blowing stuff! This information will change lives. We hold the keys to our freedom.

When we are intentional with our thoughts and words, we decide how we think, feel, and act. Every. Single. Time.

In the book, *"The Happiness Advantage"*, author Shawn Achor explains that when we make even tiny moves toward being more positive it can change families, organizations, and communities.

Every time we choose one tiny positive thought, another ANT dies. They can't live in a positive environment. Change your thoughts, change your world!

See 'em to Destroy 'em.

Backsliding.

But thoughts are not so easy to change, are they? In order to save energy, our brains take what we repeatedly do and automate it. That way, we don't have to relearn how to brush our teeth, walk, talk, or feed ourselves.

Our brain does the same thing with our thoughts. Automates them. Our brains don't care if the thought is positive or negative. So, if we are not careful, we end up infested with ANTs and those ANT's become part of our operating system. Our operating system is how we show up in our lives.

> **Every time we choose one tiny positive thought, another ANT dies. ANTs can't live in a positive environment.**
>
> *Cindy Bayles*

Fighting Invisible Enemies.

How do we fight something we don't know is there? How do we delete thoughts we don't know about? It's like fighting an invisible enemy! A powerful enemy. An enemy that can make or break our lives.

I have used the following thought weapons against myself:

- You are not good enough.
- You can never do that.
- Aren't you better at this?
- You screwed up. Again.
- You should be embarrassed.
- If he/she changes, then you will be happy.
- God doesn't hear you.

Weapons I have used against myself are:

- You are not good enough.
- You can never do that.
- Why aren't you better at this?
- You screwed up. Again.
- You should be embarrassed.
- If he/she changes, then I will be happy.
- God doesn't hear you.

Cindy Bayles

Get Them Out of Your Head!

How then does someone see their subconscious thoughts? How does one know if one is infested with ANTs?

Dr. Amen suggests what I call a thought download. We write down all of our thoughts without editing them. This way we see what we are really thinking. This gets the ANT's out of our heads and onto paper.

This exercise takes about 5 minutes a day. And I promise you, it's worth the effort.

It's time to take our power back. It's time to defend our minds and hearts. We have allowed our ANTs to take up residence in our hearts and minds for far too long.

Thought downloads get the ANTs out of your head and onto the page so you can see them.

Cindy Bayles

Thought Download.

I have preached about thought downloads for a long time. However, I was downloading my thoughts only occasionally. Like when I was feeling particularly irritated. Writing down all of my thoughts when angry has been very helpful and enlightening. It helped me to get some traction when I was caught up in my emotions.

But I wasn't getting long term relief. The thoughts around the incident were out and on paper but I still had another 66,564 thoughts rolling around in my head. Thoughts that were not serving me. Honestly, I was just band-aiding my ANT infestation.

Daily Practice.

I wanted better results. But, if I wanted better results, I would need to be consistent in my daily practice. So, I committed to doing a thought download every day and seeing what might happen.

I chose a topic and started on Day 1. That topic? Writing this book. I was super stuck in book-writing mud. I hadn't made real progress for months.

During the first few days, I filled up my page with complaining. Then one morning, I wrote all of the ways writing a book was awesome. Then, I started making progress. I finished 4 chapters in 2 days.

Yay! For progress and thought downloads!

Are you band-aiding your Automatic Negative Thoughts (ANTs) infestation?

Daily Thought Downloads.

Rubber Bands.

When I was a kid, my mother was on a diet. She wore a rubber band on her wrist. She would snap that rubber band every time she broke one of her weight loss rules. At the time this was the way to change behavior. This is negative reinforcement. It's the way most of us learned to improve ourselves.

We beat ourselves up for making mistakes, not being perfect, and being too slow. Negative reinforcement doesn't work. There is a better way.

Positive reinforcement is a different animal. We can make a huge shift in our mindset and our lives with this simple tool.

Cans of Grain.

My husband and I have a couple of horses. We moved them to a larger property this summer. But we wanted the horses to come to us when we were on the property. So, every time we went out there, we took a can of grain, honked the horn, and then waited.

The first few times, we had to find, catch, and feed the horses the grain. But after multiple times, the horses showed up minutes after we arrived, ready for their grain. The horses would never have come to us if we had yelled, chased, or beaten them.

Celebration Wins.

We train ourselves with celebration. Celebration is the reward we use to train ourselves.

We celebrate ourselves when we experience the behavior we want. As we ignore the behavior when we don't live up to our expectations.

So, when it comes to ANT's, we high-five ourselves every time we redirect our thoughts to an empowering thought. We celebrate our success when we download our thoughts. That's it. Doing this one simple thing yields miraculous results!

Celebration improves our happiness and well-being. Celebration is as important as the daily practice of gratitude, mindfulness, and meditation.

> **Celebration is as important as practicing gratitude, mindfulness, and meditation.**
>
> *Cindy Bayles*

Simple Shift.

We want to make changes today and have long-lasting results tomorrow. That's the dream, right? But change is not an overnight process.

We have already tried the quick fixes. It's time for long lasting healing. Habit stacking is the key to real change and growth. You choose one tiny habit and focus on it until it's solidly anchored into your life. Then you stack another habit on top of that one.

So, you could start a simple new habit of doing a **thought download** every day. You could spend five minutes emptying out your brain. Then celebrate by punching the air and saying, "Good job!"

Thought Download.

But too often I give up before I have time to see the results. Simple daily habits mold who we are and create our future.

It took me a while to make daily thought downloads my new normal. Thought downloads keep my brain clean. Just like brushing my teeth every day, keeps my teeth healthy. Thought downloads clean the ANTs out of my brain.

The more consistent I am, the happier I am. Are you ready for life-changing results? I have a weekly habit tracker that helps me to be consistent.

Tracking creates awareness and therefore movement. Tracking in our heads doesn't work. It is too easy to forget and/or lose interest. The habit tracker is the key to sustainable change. It reminds us of what our new thought is. It keeps us on track when it feels easier to quit.

With this one simple tool, **you can alter your life's trajectory, one single thought at a time.**

Try the thought download for 30-days. You will be glad you did!

Doodle Therapy
Infestation Doodle

Doodle along with me. We will doodle a brain with a 90% ANT infestation. Then we start deleting each ANT by replacing an ANT with a new automatic positive thought.

Supply List:

- 1 Mixed media paper or cardstock paper.
- Watercolors, crayons, markers, etc.
- Pencil.
- Waterproof fine tipped marker.

1. Doodle a circle in the center of the page. (Make it take up most of the height of the page.).
2. Draw a diagonal line through half of your circle. Then make a face in the right half of the circle.
3. Journal Prompt: What thoughts are hurting you?
4. Draw thought bubbles inside of the top part of your head.
5. Using a pencil, doodle ANTs inside 90% of your thought bubbles.
6. Journal Prompt: What do you believe is true about you?
7. Ask yourself these empowering questions to find your ANTS about your thoughts.
a. Is this thought 100% true?
b. Could this thought be proven in a court of law?
c. Does EVERYONE believe this thought?
d. If the answer is "No." to any of the questions.
8. Erase on or your ANTs.
9. Journal Prompt: What is a new positive thought you could replace one of your ANTs with?
10. Doodle a sun or heart in the ANTs place. Sun = Joy and Heart = Love.

Infestation Doodle

This is an unfinished Doodle ANTs. You can use it as a guide, finish it, and/or color it.

To access the free Doodle Healing Workbook,
go here: *https://doodletherapy.groovepages.com/book-free* or use this QR code: Get the habit tracker and a list of positive automatic thoughts to replace your ANTs with.

7
Doodle Story

"Whether you think you can or you think you can't. You are right."

~Henry Ford

Power Story.
Radio Show.

Camping was a common summer adventure for my cousins and I, during our youth. While camping, we loved listening to the thriller radio show with Vincent Price. All of us would gather in someone's tent, blow out our lanterns, and switch on the radio. The radio crackled, as we found the station and waited for that night's thriller to spring to life.

Those tales of murder and mystery could raise the hair on the back of our necks. We held our breath as the story unfolded and were petrified to venture into the dark alone.

We Love Stories.

We as humans thrive on stories. We live vicariously through the various characters, events, and circumstances. We fear for the damsel in distress or step into the warriors' shoes without actually being in danger ourselves.

When hearing a story, the language processors, emotional centers and imaging parts of our brains are activated, creating an all-encompassing experience. Our brain and body react as if the events are actually happening.

Meaning we may feel multiple emotions throughout the tale. We love stories because we feel the emotions without living through the events.

The same thing happens when we recall past memories.

True Stories.

A memory is an interpretation of an event. When mixed with emotion, our brains stamp an event as important, so we don't forget it.

This is our brain's way of protecting us. Our brains create a trigger so that we can be prepared if a similar event were to reoccur. This can protect us or leave us hiding. We must look closely at our stories and see if they empower us or keep us stuck.

We can create new memories and therefore new beliefs. With every retelling, that belief becomes embedded into our subconscious.

This gives us the power to create who we are and what we believe.

Our beliefs have the potential to hold us back or encourage us to rise.

> **Important!** When mixed with emotion, our brains stamp an event as important, so we don't forget it.
> *Cindy Bayles*

Maya's Story.

An example is how 7-year-old Maya Angelou created a new belief. Maya was raped by her mother's boyfriend. Her rapist threatened to kill both her and her brother if she told anyone. So, Maya tried to cover up the evidence of being assaulted. However, her brother, found her bloody panties and Maya revealed the truth.

The molester was arrested, tried, and found guilty of rape. But the rapist was only sentenced to 1 year and 1 day in jail.

For unknown reasons, Maya's molester was released immediately after the trial. That night the convicted rapist was found kicked to death.

Distorted Thinking.

Upon hearing of his death, Maya quit speaking. Her 7-year-old brain believed that her tongue had killed her rapist. No amount of cajoling could change her mind. Maya
remained mute for the next five years.

Although it is easy to pinpoint young Maya's distorted thinking, it doesn't change that she spent five years mute.

However, Maya is no different than you or me. We all have a unique internal operating system. Some beliefs help us, and some hurt us. Unfortunately, our beliefs can keep us stuck.

Unfortunately, our beliefs can keep us stuck.

Does this filter empower me?

Cindy Bayles

Stories Define Us.

Story Filters.

Understanding how our beliefs shape our thoughts, emotions, and actions provides valuable insights into our behavior.

It is estimated that 90 percent of our thoughts are unconscious. This means that the majority of our actions are automatic. Many of our unconscious thoughts were created while we were too young to make sense of the world.

Our stories have a powerful impact on how we interact with our world. These stories act as filters through which we see our experiences. Our fltters may affect our mood, relationships, job performance, self-esteem, and our physical, mental, and emotional health. Thus, we define ourselves by our stories.

Stuck In the Past.

We may use the past as an excuse to stay stuck or as a reason to push forward.

Both trauma and achievement form our beliefs. Our beliefs create feelings of being worthy or worthless, powerful or powerless, trusting or suspicious, belonging or outcast, self-reliant or dependent and empowered or victimized.

Each of us is powerfully controlled by a confirmation bias. We practice confirmation bias when we search for, interpret, favor, and recall information in a way that supports our beliefs or values. This controls how we react or don't react to our circumstances.

> **Both trauma and achievement form our beliefs.**
>
> *Cindy Baylés*

Money Story.

We learn and retain information from our experiences. That's good. However, many of us allow our beliefs to cripple us and keep us stuck.

Each of us has varying beliefs about money. Some of our beliefs hurt us and some help us. Because of our beliefs, we may treat money very differently.

I was raised by a grandfather, who happened to be a millionaire. I didn't love him because he had money. I loved him because of how he treated me. He was a humble and kind man, a farmer and rancher, who started his workday at 3am and wore his jeans until they were thread bare.

Dirt Poor to Millionaire.

My grandfathers went from dirt poor to becoming a millionaire. During the depression my grandfather worked for a farmer to support his young family. Little by little, he saved enough to buy a small farm. However, he couldn't quit his job until the land could support them. So, he, my grandmother, and their newborn baby spent their nights tilling, sowing, and planting their farm. In the morning, my grandfather headed to his job. This continued until the farm could support them.

From these humble beginnings he created an abundant life.

Different Beliefs.

My grandfather's story created powerful beliefs for me.
I believed that money was:
- Good.
- Required a lot of hard work.
- Could help others.

However, as I grew up, I noticed how others treated people with money. My beliefs around money started shifting. "Money is shameful" was added to my money story. This change happened without me realizing it. My old beliefs and new beliefs created an unhealthy relationship with money.

My beliefs morphed into: Money comes with great sacrifice, there is never enough, and having money is shameful.

Empowering Beliefs

Stop Blaming.

So how do we get out of this sticky situation? If our beliefs are part of us, how do we set ourselves free?

We create a different story that empowers us. We tell ourselves this story while looking for evidence to support our new belief. Changing our beliefs on purpose gives us power. Power to stop blaming our mother, brother, teacher, or the president for the circumstances of our lives. We can create beliefs that encourage growth, forward movement, and masterpieces we never imagined.

Courageous Warrior.

When our beliefs empower us, we are unstoppable. We know it's only a matter of time before we reach our goals. Step by step, we transform with consistent action.

It takes courage to rewrite your story, to create new meaning from old facts, to let go of being a victim, and to become a warrior. You can examine your stories and decide if your belief is worth keeping or if it is time to let it go.

When you transform your victim story it can turn into a hope filled, redemptive, and power story.

Fight For You.

When we dismantle the beliefs that keep us stuck, we make progress. As we take tiny steps toward our destination, we transform into entirely different people. Belief by belief, we move the mountain that says we aren't good enough. As each rock is moved, we catch glimpses of the future God has in store.

We are no longer afraid of failing. Instead, we understand mistakes are part of learning. It is a journey to the place God planned for us. It's not a matter of maybe. It is a matter of faith. Faith in ourselves and faith in God.

Moving Mountains.

Our stories are diverse. Our stories may be painful. Our stories define who we are. We can rewrite our stories.

That's when the magic happens. We stop repeating our old stories that tell us to sit down and shut up.

Our new stories empower us to stand up and be seen. To become the mighty warriors, we were meant to be. To stop sitting quietly on the sidelines and to live courageous and joyful lives.

When we let go of what we believe is true and take hold of what's possible, miracles take place.

God's Story.

That's the way God works. He plants the belief in who we can become. Then encourages us to become our divine self. We mistakenly believe if God wanted this for us it would be easy. When the opposite is true. We must get uncomfortable and do things we have never done so we can become who God would have us be.

That's why we love stories. We want stories of triumph, overcoming, and victory. That's what our stories can be. A story of how the mountain blocked our way and taught us who we were.

Growth.
Seeds.

The stories we tell ourselves create our **beliefs**, our beliefs create our **emotions**, our emotions create our **actions,** and our actions create our **results.**

It's like planting a seed. We reap what we sow. When we plant an apple seed, we get an apple tree. What you believe will yield the fruit that you plant.

My new thoughts that I am planting are:
- I love and accept you.
- I honor who I am.
- I am a divine daughter of God.
- I can do all things through Christ who strengthens me.

What thoughts empower you?

> **What you believe will yield the seed that you plant.**
>
> *Cindy Bayles*

Weeds.

Sometimes, we have beliefs that are not serving us. They are weeds of the mind. There are always going to be weeds that spring up in our gardens. Some of them have roots that go to China.

These are some of my weeds that have made their home in my mind:
- I have nothing to offer.
- I can't do anything right.
- I need to learn more.
- I talk too much.
- No one notices me.

Instead of trying to pull the weeds of our beliefs. It works better to identify a belief that is not serving us and then add a positive belief, this creates flexibility in our thinking.

Sunshine.

Because we see our experiences through the lens of old assumptions, we don't look for evidence that our new belief could be true. Far too often, I get stuck trying to prove my old, unhelpful, belief. I see it in myself, my family, and my clients. We don't allow ourselves to believe or feel differently about ourselves.

We can choose to believe something new. These empowering questions will illuminate your story so you can see if it serves you.
"Does this thought serve me?"
"Does this belief give me courage?"

Water.

Even if we want to have a new belief, we can't just hope to create one. We must water it by looking for ways this new belief is true. If I am looking to create a new belief, then my first step is to post that thought where I can see it every day.

I then look for the ways the belief is true. At the end of the day, I record the proof I found that the new thought is true. This is how to create evidence about a new belief.

Harvest.

There is clarity and freedom when we look closely at how we see and interact with our world. When we question our beliefs and open our hearts to believing something new, we find truth.

This is a journey and not a sprint. Start by taking one belief at a time, figuring out what results you are getting, and decide if the belief is serving you or if you should let it go.

Start by planting a seed, water it, give it light, and allow it to take root. There is a bounteous harvest ahead my friend. A harvest you never thought possible. Just from planting a seed and nurturing it.

Your Power Story.

Choose Your Story.

During Maya's silent five years, she read every book in the black library and the white library, learned to love poetry, and memorized seventy-five poems.

As Maya was reading a poetry book., one of her teachers challenged Maya. She stated, "Maya, you don't love that poetry." Maya emphatically nodded that she did. Her teacher said, "You can only love poetry if you read it out loud."

So now Maya held two opposing beliefs. One that her tongue could kill a man and another that she could only love poetry if she spoke it. So, she discarded the first belief and clung to the second. Thereby changing her world and ours.

Maya Overcomes.

Maya was considered one of the most consequential figures of the 20th century. She was a singer, dancer, journalist, civil-rights activist, author, poet, and screenwriter.

Her autobiography *'I Know Why the Caged Bird Sings'* was a 'New York Times' bestseller for two years. She was the first Black woman to write a screenplay for a major film release. She recited her poem, "On the Pulse of Morning," for President Bill Clinton's inauguration. Making her the first African American poet and first female poet to participate in a recitation for a U.S. president's inauguration. She was bestowed the 2010 Presidential Medal of Freedom by President Barack Obama, the highest civilian honor in the United States.

Power Title.

The title of Maya's story could have been The Voice That Changed The World. Her silenced voice was powerful. Maya used her voice to sing, recite poetry, write articles, speak, and advocate for civil rights.

My power title is: I am a powerful creator.

What's Your Power Title?

Creating a new belief for myself gave me courage to write a new story. A story of power, redemption, and courage. he story of becoming the person I never believed possible.

Heroic Overcoming.

So, I set out with some big goals. Goals that I had never considered. I ran into obstacles along the way. The biggest obstacle was my habit of avoiding emotions.

I was afraid of facing the emotions my stories brought up. Fear kept me stuck and hiding. I had to become willing to process my emotions so I could figure out what they were trying to tell me.

I have spent way too much energy trying to avoid feeling negative emotions, like sadness, guilt or shame. But each of these emotions has something to teach me if I will only listen.

A New Ending.

It takes courage to open our mind's door and take a look inside. We blindly live our lives running on auto pilot. Never stopping to look around and see what is and isn't working. We keep wondering why we are getting the same results year after year after year. We won't know what those beliefs look like until we open the door and put those thoughts and emotions on paper.

Then we can craft an ending we never believed was possible. An ending that only we can choose.

Doodle Activity
A Warrior's Story Doodle.

Doodle along with me as we rewrite our stories. We will start with our victim story, then share the messy middle, and finally end with our victory. This is an exercise in seeing and feeling how powerful we are. Don't hold back. Share all of it. No one needs to see it.

Supply List:

- 2 Mixed media paper or cardstock paper.
- Stapler, tape, or yarn to bind your book.
- Watercolors, crayons, markers, etc.
- Pencil.
- Waterproof fine tipped marker.

A VICTIM STORY

Start with 2 sheets of paper. The first sheet will be used to write a victim story.

Stories have villains, heroes, and victims. This is the story of how you felt like a victim. Use the following prompts to help you write your story.

1. Who is the villain in your story?
2. How did the victim affect you?
3. How did the victim hurt you?
4. How did the villain's actions affect how you see yourself?
5. How were you the victim?
6. Tell your victim story.
7. Start writing your story with:
 a. "Once upon a time, there was a _____,"
 b. Don't edit, just write what comes out.
 c. Add doodles to enhance your story if you like.

A WARRIOR STORY

Use the second sheet of paper for your warrior story.
This is a story of how you became or will become the hero of your story.

1. What did you learn from this situation?
2. What do you need to do in this situation?
3. What do you need to believe to become a warrior?
4. How did these events happen FOR you?
5. What did you gain because of this?
6. Don't hold back, write about how courageous, strong, and resilient you are.
7. On the front of your book, write your title. Mine is: My Warrior Story.
8. Add a doodle to the finish your cover.

To access the free Doodle Therapy Workbook, go here: *https://doodletherapy.groovepages.com/book-free* or use the QR code to download the free workbook. The workbook has space to record your warrior story and as always, the finished and painted doodle.

A Warrior Story

This is a cover for My Warrior Story. You can use it as a guide, finish it, or color it.

8
Doodle Vision

> Where there is no vision there is no hope.
> ~George Washington Carver

Life Journey

Exposed.

"I feel like I am naked, in my bedroom, with the entire world watching." I told our marriage counselor. Every boundary in my life had been destroyed. Leaving me feeling totally and utterly exposed.

Exposed to judgment. Exposed to my failures and weaknesses. Exposed to shame. Exposed to pain.

When my husband said the words "I want a divorce", a hurricane swept through my life leaving only devastation.

The life we had built together was no more. Our future hopes and dreams, obliterated. I was naked, afraid, and wondering how the hell we ended up here.

Afraid.

While I prepared to turn fifty, I assumed it was too late to start over. Not having earned my own paycheck in three decades, I couldn't imagine what my future held.

As I grappled with what to do, my husband resigned his position as chief of police. Leaving us both unemployed. I was terrified. We had children, a mortgage, and bills to pay. The terror and shame threatened to swallow me whole as the wolves growled at my door, hungry for juicy gossip. The chasm of fear grew ever wider.

Don't Screw Up.

I had spent my life living as safely as possible, carefully avoiding tragedy. Whether that tragedy was divorce, death, sickness, or an accident. It didn't matter. I reasoned, if I followed the rules, we might make it out in one piece. That meant doing everything exactly right.

My strategy was to not screw up. I was shooting to live with the least amount of pain possible. My plan was designed to keep us safe.

However, as I made safe choices, I avoided living my life to its fullest. A life of success mixed with failure, and joy mixed with sorrow.

Expectations.

By avoiding the hard, I missed out on life's beautiful peaks and glorious valleys.

I spent my days avoiding physical and emotional pain only to realize it's about the contrast. A good laugh and a good cry. The pain and the joy of birth. The love and sadness of grief. They are all wrapped up in a package that we don't always want.

I had a picture of what my life should look like. But it was my expectations that kept me stuck. When I clung to what life **should** look like, I focused on what was missing. Instead of looking for what I could be grateful for.

Decide What You Want.

Clinging to my expectations kept me stuck. It's hard to find joy when nothing looks like you think it should.

So, I made a list of what was serving me and what needed to be discarded. I lowered my expectations of what should be and raised my standards of what was acceptable in my life. It was time to do something different. It was time to throw out old habits, dreams, expectations, and plans that no longer served me.

Feeling uncertain, I stood at a crossroads, unsure of the path ahead. Yet, in that moment, I realized it was up to me to shape what lay ahead. The time had come to take responsibility for whatever lay ahead.

Map Burning.
Light a Match.

It was time to burn the map I had clutched my entire life. The map of expectations. The map that held my hopes and dreams. It was time to let it go. It was time to create new possibilities. Possibilities full of high peaks, deep valleys, and amazing adventures.

So, I tore up my life map, and lit a match.

What about you? What do you want your life to look like? Feel like? Sound like? Be like? You get to decide what you want, love, and need. It's your life.

Go ahead, take a look at your expectations, dreams, habits, and plans. Is this the life you want?

Light Up Your Life.

Looking closely at our lives is scary. We might see things we don't want to see.

So, we pretend there is nothing wrong. But ignoring the monster behind the door is more frightening than looking it in the eye.

Strike the match. Burn what isn't serving you and watch your life light up.

Cindy Bagley

140

We are so worried about losing our life, we don't realize it's not what we want. We're buried under the should haves and the need tos ad nauseum. **Imprisoned in a life that we are not ok with.**

You get to decide who you will and won't be. **Strike the match.** Burn what isn't serving you and watch your life light up.

Born With a Spark.

Every one of us was born with a spark. Whether that spark grows into a flame or flickers and dies is up to us. That spark was placed in us by God. We can ignore that tiny spark, refuse to breathe life into it, leave it to smolder, or nurture it until it is an unquenchable flame.

We create a roaring bonfire when we focus on the end result, take the next step, and get rid of what dampens our fire.

Breathe light into your spark by asking:

- What is awesome?
- What needs work?
- What can I do differently?

Arise From the Ashes.

Celebrate where you are and what you have accomplished. Celebrate the big wins and the small wins. Let thedisappointments and heartaches disperse with the smoke. Watch as that smoke transforms into hope, courage, and excitement.

Boldly arise from the ashes. Release the shackles of fear, belief, and perception that no longer serve you.

> **Boldly arise from the ashes. Release the shackles of fear, old beliefs, and faulty perceptions that no longer serve you.**
>
> *Cindy Bayles*

We fear being seen, making mistakes, and doing things differently. We believe doing something different will upset the balance of things.

Try these new thoughts.

- "Maybe, I have something to offer the world."

- "It's possible I hold more power than I ever imagined".

- "What if I change my world?"

You Were Made to Sparkle.

It takes courage to step into what you are capable of. To see who you really are. Ponder on the possibilities. Look for your flicker of light to show you the way. It's been there all along. You couldn't see it because your map was limited. You are enough.

You are more than enough. You have something powerful to give the world.

You have a journey ahead of you. It may not be an easy one. But the light is on the horizon and it's time to prepare.

You have work to do, that is yours alone.

Navigation.

My Journey is Your Journey.

It doesn't get more real than this, my friends. My journey is your journey. Even if your circumstances are different from mine, we each have a map. Maps that need adjusting, are going nowhere, or need to be burned.

The truth is life's path is not an easy one. There are peaks and valleys along the way. We will get bloody, bruised, and hurt along the way. It's scary out there! Because we are afraid, we give up our ability to make choices and in so doing give away our lives.

Follow that Car!

Sometimes, when I am lost in the city, I scan the cars and find one that I think looks like it might be going where I am going. And then I follow it. No really. I do that.

Do you know how often I arrive at my destination when following a random car?

Take a guess. I'll wait....

You're right.

ZERO!!!

Weird, I know. Following a random car doesn't get you where you need to go. Many of us live our lives this way. We look at others and think they know the way. So, we follow them without stopping to ask where they're going!

The Road to Hell.

It's dang hard to say, "This is who I am". Far too often we don't decide who we want to be. We take the easy road and follow everyone else, try to make others happy, or be someone else.

That's the road where there is no conflict, the decision making is done for us, and it's less scary. That road is called *"Going with the Flow"*. Or the road to hell.

Maybe that's where you want to go. If it's not, it's time to decide where you want to end up. That's easy enough. Choose. Make a choice and commit to it.

Where are You Going?

But it's easier said than done, isn't it? I mean there are a host of factors to figure out. How much will it cost, how long will it take, will I do it right, and do I want to put in the effort?

he time to vacillate is long past. Choose something and jump in. The water is just fine. You can always change your mind later. Making your own choices can be fun! You get to make choices that affect you and mold you into who you want to be.

Once you choose a destination, it's time to intentionally create a new map.

Follow the Signs.

Much to the dismay of my husband, I never believed I needed a map. I thought I could just follow the signs. Apparently, it doesn't work that way.

Do you know if you drive from Utah to Florida, there is not one sign in Utah telling you which way Florida is? You need a GPS (or map) to get there! Who knew?

Creating your personal map yields unimaginable results. When you map out your journey before you begin, you get there faster and with less trouble than you ever imagined. As you travel, look for the signs. The signs from God. Maybe, He has a better way!

Vision.

Why Create a Vision Map.

There are varied opinions on the effectiveness of vision maps and how they function. For me, it boils down to three key aspects:

Visualize: Organizing a vision map lets my imagination explore what the accomplishment of my goal looks like. As I envision the outcome, my commitment and enthusiasm grow.

Focus: Vision maps place my goal in front of me. When I check my vision map daily, something magical happens; I become proactive in pursuing my dreams.

Track: Incorporating tracking into my vision map adds potency. It not only keeps me accountable for daily action steps but also intensifies my motivation by charting progress.

Using visualization, focus, and tracking, we can reach or come close to our goals every time. That's how maps work. We visualize where we want to go, focus on the road to get there, and track our progress.

How to reach your goals.

Visualize the outcome

Track your progress

Focus on the destination

Wake Up Your Imagination!

When I sat down to create my vision map, I had no ideas and saw no possibilities. It was as if I was locked in prison with no chance of release.

Albert Einstein said: "Imagination is everything. It is the preview of life's coming attractions."

Imagination was exactly what I needed.

However, I wasn't sure if I even had an imagination anymore. I was afraid I had killed her. For decades, I hadn't allowed her to come out and play.

When I let her out, she was groggy, dazed, and confused.

Imagination Party.

I had to be patient with her. She had been ignored for too long. Together, we practiced imagining, doodling possibilities, and giggling with glee.

As we worked together, the excitement grew!

Together we created a map of exciting adventures. It would take a mighty miracle. But together we could make it happen. Sitting with my imagination, opened thoughts I had shut down for decades.

Einstein also said: "Logic will get you from A to B. Imagination will take you everywhere."

I can logic my way to a lot of things, but if I don't let imagination play a part, they are sad and boring things.

Imagination makes life exciting!

> **Logic will get you from A to B. Imagination will take you everywhere.**
> *Albert Einstein*

My Vision Map.

Creating a new vision map changed the trajectory of my life. Having a visual reminder of what was possible gave me a new life perspective. Sometimes all we see is our hand in front of our face and miss the beautiful sunset.

This process put me where I belonged, as the captain of my ship. At first, I wasn't a great captain. I had accepted the position a few times and quickly given my power away. Floating aimlessly waiting to see where I might land.

As I accepted my power, I made life altering decisions.

Choose A Direction.

Putting myself at the helm, I decided what the rest of my days would look like. I had the power to take charge of my life. It was time to claim that power.

Setting aside my worries about what others might think, I crafted a new vision. One that was designed by me, and for me.

Putting myself at the helm, I decided what the rest of my days would look like. I had the power to take charge of my life. It was time to claim that power.

Putting aside my worries about what others might think, I crafted a new vision. One that was designed by me, and for me.

I felt excitement, clarity, & direction. I was no longer tossed to and fro by the whims of others. I KNEW where I was going, and I had a plan to get there. This was life altering stuff!

Vision Map Making
Create Your Miracle Map.

Are you ready to create your own vision map? Are you ready to create miracles you have only dreamed of? Vision maps create miracles. They help us stay on course and remind us of where we are going. It won't be easy and there will be obstacles along the way. But ultimately, you will arrive at the place you dreamed of.

All it takes is knowing where you are going, having a plan to get there, and taking consistent action toward that goal.

Rule number one: Let go of perfectionism. **Perfectionism** will keep you from starting, slow you down, and stunt your imagination.

Brainstorm.

Now brainstorm a list of everything you want to create this year.

Organize your list into categories. Such as:

- Family
- Legacy
- Health
- Travel
- Money
- Relationship
- Education
- Spiritual

Look over your list and choose your top eight. Choose one goal that if you accomplish it, everything will change! And circle it.

Make 8 squares depicting each goal and write the due date on each. Make the most important one stand out. This will be your focus.

Here is where the magic happens.
- What will it feel like, look like, and be like when you get there?
- What steps will you need to take to get there?
- When do you want to accomplish this?

This is your miracle vision map. The map that creates miracles. These are your goals.

Focus.

Maybe you stop right there. Maybe your one most important goal is the only thing you want to focus on. Sometimes we push ourselves to do more than we are capable of.

When we have a pile of goals we want to achieve, we pile so much on ourselves, we can't get anywhere. Like the straw that breaks the camel's back, we can only do so much. Ask yourself if you can or want to do more.

In Chapter 11 Doodle Focus we will go deep on choosing the one thing.

Visualize.

We are not forgetting the other seven; we are FOCUSING on the one. Just like ignoring a map or GPS makes it useless. An ignored vision map is also wasted.

Set a reminder to look at your vision map twice a day. That way you know what steps you need to take, where you are going, and how to get there.

When the reminder goes off, review your steps, acknowledge the obstacles, envision yourself getting the goal, and celebrate your progress.

This focuses your mind on where you are going, creating consistent progress toward your ultimate destination.

Visualize, Focus, and Track.

Recently, I remodeled my bathroom. I visualized the bathroom completed with new powder blue paint, lighting, tile floors, mirror, towels, rugs, and shower curtain. Then I planned each step. I was obsessed with getting that project done and excited to see it finished. That's what creating a vision map does.

With your vision map in hand, you have the power to create things you never thought possible. Creating a life on purpose.

It surprises me how fast miracles are created when I follow these steps consistently.

We can't wish our way to Paris. But we can create a map, take the steps, and get there every time.

We just need to visualize, focus, and track.

> **With your vision map in hand, you can create a future you never thought possible.**
>
> *Cindy Bayles*

Doodle Activity
Arise from the Ashes Doodle.

Doodle along with me as we doodle you arising from the ashes of what no longer serves you. And using powerful words about yourself signifying you have gained strength, courage, and resilience.

Supply List:
- 1 Mixed media paper or cardstock paper.
- Watercolors, crayons, markers, etc.
- Pencil.
- Waterproof fine tipped marker.
- Matches (optional)

1. Cut your page in half.
2. Journal the following on one half of the page.
3. Journal Prompt: What has disappointed you in your life
4. Journal Prompt: What has surprised you in your life.
5. Journal Prompt: What is no longer serving you?
6. Cut out each answer to the question, "What is no longer serving you?"
7. Using a marker black out what is no longer serivng you. Make them look like they have been burned.
8. Or you can have a burning ceremony. (Please be careful and do at your own discretion.)
9. Glue the blacked-out pieces or burned pieces at the bottom of the page. Creating a mound of ashes.
10. Doodle You arising from the ashes. (Make her dirty and scuffed.)
11. Write on your doodles dress, powerful words that she exemplifies.

Arise from the Ashes

Use this unfinished Arise from the Ashes doodle as a guide, to finish, as a guide, and/or color.

To access the free Doodle Art Therapy Workbook, go here: *https://doodletherapy.groovepages.com/book-free* or use this QR code. Download the workbook to get a supply list and ideas to build your own vision board.

Section 3
Doodle Strength

9 Doodle Crown

"I have come to believe that caring for myself is not self-indulgent. Caring for myself is an act of survival."
~ Audre Lorde

Self-Care
Quitting Life.

When my husband asked for a divorce, I shut down. I had been going full speed ahead in every area of my life and I just stopped. I had nothing left to give.

I felt like I was moving through thick sludge. I just couldn't continue any longer. I said "No." to anything that wasn't necessary. I said, "No." to intrusions, and I stopped worrying about what people thought.

I realize now this was self-care. I was drowning. I had to take care of myself or die. I gave myself space to breathe, mourn, and heal.

A New Life.

I stopped pretending, and worrying about what other people thought about me, needed from me, or asked of me.

Slowly, I added new habits into my life. These new habits included daily prayer, journaling, thought downloads, online courses, yoga, meditation, scripture study, running, gratitude journaling, painting, affirmations, listening to my song, remodeling my office, reading books, and becoming a life coach.

I have no idea why I implemented so much self-care. But I did. If you ask my children about that time, they will probably say that I abandoned them. This is what self-care looked like for me.

Self-Care Craze.

I was well into adulthood before I heard the term self-care. It was a foreign concept to me. It was usually followed by a list of things that the author considered to be self-care. Things like getting a manicure or pedicure, taking a bubble bath, or getting a facial. As a busy wife and mom, I couldn't figure out who had time for such things. It definitely wasn't me.

Bubble bath?

Really? I couldn't go to the bathroom without someone banging on the door!

So, I blew off the self-care idea as just another thing to add to my list.

What is Self-Care?

The term self-care means different things to different people. My definition of self-care is deliberately taking care of ourselves.

'Deliberately' being the most important word in this definition. When we are deliberate about giving ourselves what we need, desire, and want. Then we are practicing self-care.

But let's be honest. Most of us are not deliberate about our needs. Who has time for that? It might even sound selfish and narcissistic. So, most of us pay little attention to our needs until we are physically ill, emotionally exhausted, or have ruined our relationships.

Time to Start.

> *Queens* **prioritize their own care. Treating yourself like a queen reflects how you** *deserve* **to be** *treated*.
>
> *Cindy Bagley*

Self-care is learning to slow down and put your needs first. Not second, third, or last, but first. A queen prioritizes her own care. Treating yourself like a queen reflects how you deserve to be treated.

This was mind-blowing stuff for me. My lack of self-care had left me cranky, sad, sluggish, irritable, and exhausted.

Honestly, I had begged myself for some relief. But I told myself that there was no time for such frivolous things.

How many times have you put off that child inside of you? The one begging for some love and attention? I was constantly telling her there is no time to love, care, or nurture her. It was time to treat myself differently.

Neglecting Self-Care.
Warning Signs

Sixteen Warning Signs you are neglecting yourself.

- TAP TAP TAP — Impatient
- Change in sleep patterns
- Low energy
- Indecisive
- Worsening mental health
- Concentration issues
- Feeling hopeless
- Feeling unworthy
- MEH — Disinterested
- Appetite changes
- Urges to eat comfort food
- Feeling unwell
- Strained relationships
- Burn out
- Challenges in choosing healthy food
- Emotional outbursts

160

Our minds, bodies, and souls signal when something is wrong. All too often, I dismissed the signs because I was too busy for such nonsense. However, as I became more attuned to myself, I realized that many of my complaints stemmed from neglecting myself.

16 Warning Signs You Are Neglecting Yourself.

- ☐ Low energy and sluggish.
- ☐ Feeling of hopelessness.
- ☐ Having less patience with everyone.
- ☐ Appetite changes.
- ☐ Emotional outbursts.
- ☐ Disinterested.
- ☐ Trouble making decisions.
- ☐ Feeling unworthy.
- ☐ Feeling unwell.
- ☐ Change in sleep patterns.
- ☐ Challenges in choosing healthy food.
- ☐ Urges to eat "comfort" foods.
- ☐ Worsening mental health symptoms.
- ☐ Burnt out.
- ☐ Difficulty concentrating.
- ☐ Strained relationships.

Ignorance is Not Bliss.

Ignoring our mental and physical health can lead to a decline in overall well-being. This results in increased stress, fatigue, and decreased productivity.

Not getting enough rest and relaxation leads to a weakened immune system, making us more susceptible to illness and

disease. Not taking time for ourselves can lead to feelings of loneliness, isolation, and depression.

Ignoring our emotions can cause us to disconnect from our emotions, leaving us feeling emotionally numb. Also, a lack of self-care can lead to burnout, leaving us feeling overwhelmed and unable to cope with everyday life.

Unwanted Consequences.

I don't want any of these consequences. And yet, I don't have a great track record of taking care of myself.

When self-care is neglected, the consequences add up. For example, when we don't prioritize sleep, exercise, or eating healthy foods, our bodies feel sluggish, and we have low energy. We all know this. But pretend it doesn't pertain to us.

When we have low energy and are sluggish, we may feel hopeless and when we feel hopeless, we are more likely to be impatient with ourselves and others. It's easy to see just how quickly these symptoms can add up.

Surviving vs. Thriving.

I have definitely struggled with many if not all of these symptoms. I was always looking for the culprit in anything except for my own self-care.

Maybe you are struggling with these symptoms in your life as well. Maybe it's in only one area or maybe multiple areas. Could it be a lack of care for yourself? Developing self-care practice doesn't happen overnight. But it is a doable, amazing, and a life-changing experience.

We have neglected our minds, bodies, and souls for far too long. It's time we took care of our basic needs. Then we can move to what we need to thrive.

What Do You Need?

As my husband and I worked on ourselves, I did something I had never before done, I asked myself what I needed. This is a question I had never thought to ask myself. I had no idea that not taking care of myself was hurting me and my relationships.

As my husband and I worked on ourselves, I did something I had never before done, I asked myself what I needed. This is a question I had never thought to ask myself. I had no idea that not taking care of myself was hurting me and my relationships.

I was just worried about getting all of the things done. I thought if I got everything done on the list, then I would feel better, kinder, and freer. You know THE list. We all have one. The list that never ends. Yes, that list.

Put Yourself First.

Intentional Self-Care.

Being intentional about self-care leads to positive effects on our physical health, mental health, and overall well-being. Practicing self-care reduces stress and anxiety, improves sleep, and helps us develop better habits.

Self-care helps us feel more connected to ourselves and to our purpose. Caring for ourselves gives us a sense of control over our lives. Although it looks different for each person, it's important to find activities that work for us specifically and make us feel our best.

Many times, we implement self-care from a list someone created. While that list has great ideas, self-care is very personal.

> **Many times, we implement self-care from someone else's list. While their list might have great ideas,** *self-care is personal.*
>
> *Cindy Bagley*
>
> *Your list is not my list.*
>
> My list

Self-Care Helped Me.

When I decided to take charge of making myself feel loved, happy, and fulfilled; my life changed. I quit ignoring my needs, trying to change people so I could feel better, and making others responsible for my happiness. Instead, I worked on creating my own happiness.

This is life-changing information folks. Let me say it again. It is no one's responsibility to make you happy! It is your responsibility to make yourself happy!

I asked myself powerful questions I had never asked myself before. Those questions included:

> **It is your responsibility to make yourself happy!**
> *Cindy Bayles*

Practicing Self-Care.

1. What do you need? The first step to self-care is to recognize what it is that you need. Think about the areas of your life where you could use some extra support.

2. What kind of self-care routine would fit into your daily life? This could include things like taking a walk in the park, listening to music, or doing yoga.

3. What tiny goals can you set for yourself? How can you make it easy to achieve? A tiny goal could include things like dancing for 30 seconds, meditating for 30 seconds each morning, or something else you enjoy for 60 seconds. Set yourself up to succeed.

Create a Self-Care Plan.

Consistency is the key to self-care. We need to make ourselves a priority. Even if we are the priority for just thirty seconds. That's a good start!

Self-care is the journey of a lifetime. It isn't a one-time thing. It will take time, patience, and practice to develop a healthy relationship, healthy routines, and healthy habits with yourself. Take it slow. It's all about the journey.

You don't have to do self-care alone. There are many resources available to help you. Some of those resources include coaching, art classes, doodle art therapy, therapy, support groups, or online communities.

Make it fun!

> **Change doesn't have to be hard.**
>
> - **Make it fun.**
> - **Make it easy.**
> - **Make it effective.**
>
> *Cindy Bagley*

We are great at making journeys torture, aren't we? No one wants to go on a hard, torturous, and ineffective journey. That's why we quit.

So, every new habit must pass the following test:
- Is it fun?
- Is it easy?
- Is it effective?

If it isn't fun, I am not gonna do it.
If it's too hard, I won't even start!
If it isn't effective, I am out. I am so darn tired of forcing myself to do something that "might" be good for me.

If it's fun, easy, and effective, now that sounds more like it. Don't compromise here.

We don't have to make it hard.

No time.
Self-Care is Not.

Invest in yourself.

Self-care is not a one-size-fits-all solution; it looks different for everyone.

It is not a sign of weakness; it's a way to take care of yourself and practice self-love.

It is not selfish; it is essential for mental and physical well-being.

It is not a waste of time; it is an investment in yourself.

It is not a guilt trip about how you need to change in order to be good enough.

Self-care is not something that should be put off or ignored; it needs to be prioritized and incorporated into your daily routine.

30 Seconds.

This is the moment when someone who loves you calls out your BS. The BS that says you don't have enough time, resources, or energy to take care of yourself.

> **Put yourself in a place of importance.**
> *Cindy Bagley*

Taking care of yourself doesn't have to take all day, a ton of money, or a boatload of energy. Self-care can start small and grow into something beautiful.

This is about putting yourself in a place of importance, instead of being a side note. Or worse yet, an unimportant note.

Start with 30 seconds a day just for you and work up from there.

Self-Care is Not Selfish.

I have been where you are. I have been at the bottom of the list. I have not even made it to the list.

I let everyone else's priorities come before a simple self- care routine. A routine that doesn't nourish my heart, body, and soul is no way to live!

I suffered because of it. The people I loved suffered. It's hard to be kind when you are depleted. Yet, we disregard our basic needs more times than we can count.

We wouldn't want to look selfish after all. It's not selfish to take care of our bodies, allow ourselves some rest, or to take time to pray.

Be a Priority.

It's time to make yourself a priority. Make yourself a priority by scheduling time for yourself and honoring your appointment.

It's easy to put things on a calendar. The hard part is showing up like your life depended on it. We tend to dismiss our needs by telling ourselves it doesn't matter, and we can take care of ourselves later. But it does matter.

Every time you show up for yourself, you show yourself you matter. You show yourself you are important. You show yourself that you value your time and attention. You show yourself you are loved.

> **Show yourself you are loved.**
> *Cindy Bagley*

No Time to Be Sick.

And if none of that convinces you, then let's talk about your health. Do you have time to be mentally, physically, or emotionally ill? Of course, you don't. None of us has time for that!

We can protect ourselves with daily self-care. Just like brushing our teeth every day, a self-care routine is daily mental, physical, and emotional hygiene.

It's amazing that a few focused minutes can improve how we see ourselves, protect us from disease, and save relationships. That's what happens when we treat ourselves like we are worth it.

You As a Priority.

Unbreakable Appointment.

To build a relationship, we have to build trust. To build trust, we have to show up. When we show up, we make that person important. Their wants matter, their needs are essential, and their feelings are important.

We know showing up matters, but we habitually let ourselves down. Disregarding our own wants, needs, and feelings.

We are good at putting ourselves off for the urgent and unimportant. It's time to honor our commitment to ourselves, to show up and show ourselves we are at the top of the list, and to be the most important appointment we make all day.

Time For You.

When we **believe** we don't have enough time, we never have enough.

When we **know** that every minute is a gift, we live in abundance, savor each moment, and carefully plan our time.

I never thought I had enough time. Time has not been my friend. I NEEDED more time. Always more. So, I procrastinated, did the most urgent thing and was always working and never took time for myself.

There is a better way! I know it sounds crazy. But we need to heal our relationship with time. How we think about time, how we treat time, and how we live with time.

Just Say "No!"

One of the biggest problems is we don't know how to say, "No". When it means we have to tell someone "No." because of our self-care routine, it might feel selfish. So, we let ourselves disregard our needs and think we will take care of ourselves later.

We don't understand that the time we set aside for ourselves is sacred time. Time that should not be sacrificed. We build trust in ourselves when we show up to our commitments. Many of us have let ourselves down so often that we don't trust ourselves to show up when we said we would. Just say "No." It will change your life.

Just say

NO!

Fun and Easy Self-Care.

It's time to decide how and when you will take care of yourself. Make a commitment to show up **when** you said you would, do **what** you said you would, and **become who** you said you would. The key is to start small and then make your goal smaller. Choose something that is fun and easy to do.

For instance, if your new self-care habit is to exercise every day. Choose something you would like to do. I chose dancing. Then set a minimum time such as 5 minutes. Fun and Easy.

Purposeful Self-Care.

When you practice any new habit by applying the **fun, easy, and effective filter,** you win every time. I know. Your brain is screaming that 5 minutes is not enough. But what if it is? What if it is the perfect way to get started? Every time you succeed, you celebrate, and your brain takes note. This is how you treat yourself, with love, care, and honor.

Take this lesson and walk through the chapters of "Doodle Healing". Allow yourself the luxury of learning and growing without beating yourself up. **Make changes that are fun, easy, and effective.** You will be surprised how much better you will feel.

Doodle Activity
Self-Care Doodle

Doodle along with me as you doodle what it looks like when you NEED self-care. Then doodle a few self-care habits you want to start.

Supply List:
- 1 or 2 Mixed media paper or cardstock paper.
- Watercolors, crayons, markers, etc.
- Pencil.
- Waterproof fine tipped marker.

1. Lay an 8 x 11 sheet of paper horizontally in front of you.
2. Doodle YOU in the center of the page.
3. On the left side of the page, doodle any warning signs you have from the 15 warning signs quiz.
4. Doodle the truth of how you feel. Are you tired? Cranky? Worn out?
5. Ask yourself what self-care you might need.
 a. What do you need? The first step to self-care is to recognize what it is that you need. Think about the areas of your life where you could use some extra care or support.
 b. Doodle these on the right side of your page.
 c. What kind of self-care routine would fit into your daily life. This could include things like taking a walk, listening to music, or doing yoga.
 d. Doodle these on the right side of your page.
6. How can you make these easy to achieve? A tiny goal could include things like dancing for 30 seconds, meditating for 30 seconds each morning, or something else you enjoy for 60 seconds. Set yourself up to succeed.
7. Doodle these on the right side of your page.
8. Doodle a crown on your Doodles head. (Because you are going to start treating yourself like the queen you are.)
9. Doodle your most important self-care habit. Write the time you will show up for yourself on your calendar.

Self-Care Doodle

This is an unfinished Doodle Crown doodle. You can use it as a guide, finish it, or color it.

To access the free Doodle Therapy Workbook, go here: *https://doodletherapy.groovepages.com/book-free* or use the QR code: When you download the workbook, get a free self-care idea guide, and a place to journal your thoughts, plans, and desires.

10 Doodle Healing

"In order to love who you are, you cannot hate the experiences that shaped you."

~Andrea Dykstra

Healing Journey

Mother's Death.

I turned 58 this year. Two years older than my mother was at her death. I never mourned her passing. I was already shut down. As the oldest child, I should have been in charge of her care, but my younger sister stepped in and did the work. That sister took care of my mother's end of life care, funeral arrangements, and burial.

I have pondered my lack of emotion. Most are devastated when their mother passes away. So, I concluded there might be something wrong with me because all I wanted was for it all to be over.

Bury Them Deep.

Don't get me wrong, my mother was a beautiful, kind, amazing, woman. But I mostly knew her as an invalid. My mom was unable

to care for herself for thirty long, agonizing, and painful years. I had plenty of emotions around her, but no understanding of how to process my feelings.

My buried emotions showed up when I least expected them, releasing them like a volcano on the ones I loved. In order to stay in control of myself, I buried my emotions and covered them with concrete.

The Gray Zone.

So, I lived a sort of half-life. I didn't allow myself to feel anything. Cutting myself off from the highs of joy and the lows of grief. If I stayed squarely in the gray zone, I could keep myself safe.

Many people who suffer from trauma live in the middle ground. Not truly happy and not truly sad, armoring up our hearts, so it won't get hurt.

There are two kinds of trauma that can affect us. The first is little "t" trauma and the second is big "T" trauma. Both can make an impact on how we interact in our world.

Little "t" Trauma.

Little "t" traumas are highly distressing events that affect individuals on a personal level but don't fall into the big "T" category. Examples of little "t" trauma include nonlife- threatening injuries, emotional abuse, death of a pet, bullying or harassment, and the loss of significant relationships.

What is highly distressing to one person may not cause the same emotional response in someone else. The key to understanding

little "t" trauma is to examine how it affects the individual instead of focusing on the event. It's easy to think that because it's not traumatic to you, it shouldn't be traumatic to someone else. Many little "t" traumas can add up to a big "T" trauma.

Big "T" Trauma.

Big "T" traumas are commonly associated with PTSD. These traumas may include serious injury, sexual violence, or life threatening events. However, a person doesn't have to be physically harmed to suffer big "T" trauma. Threats of any form of violence can also cause intense emotional shock.

Paramedics, therapists, and police officers are highly vulnerable to PTSD as they encounter emotional trauma on a regular basis. These big "T" events make people living and working closely with trauma survivors susceptible to trauma as well.

Big "T" traumas need treatment that would be likened to triage for a gravely wounded body. Individuals suffering from big "T" trauma may need professional help and guidance.

Doodle Healing

Trauma Stats.

According to the National Center for PTSD, over half of all women will have at least one traumatic event in their lifetime. Those experiences are linked to a variety of negative mental health consequences, including PTSD.

Research shows that women are more likely than men to experience PTSD, with about 8% of women and 4% of men being affected at some time during their lives. It is estimated that one in three women will face big "T" trauma by being sexually assaulted at some time in her life.

Those are high numbers of women who suffer or are suffering with trauma. However, most don't know how to deal with trauma.

Soul Wounds.

So, many of us ignore our trauma. We hope if we ignore the hurt, it will go away. That's what I did. I thought, *"I need to move on."* and *"Time heals all wounds."* Right? So, we pretend everything is fine.

The problem is if our wounded hearts and souls never get treated, they never have a chance to heal.

In contrast, if we were to ignore a broken leg and pretend it was fine, the leg would never heal properly, be excruciatingly painful, and would never work properly again.

Unhealed wounded souls are the same. **Soul Wounds** create havoc in our lives, our bodies, and our hearts.

Don't Get Too Close.

Many trauma survivors suffer from a lack of support. Empathy and acceptance for the impact of little "t" and big "T" traumas can be hard to garner because emotional bleeding is invisible.

> **Soul wounds create havoc in our lives, our bodies, and our hearts.**
>
> *Cindy Bayles*

Because trauma wounds are invisible, we humans don't comprehend how to care for each other's emotional trauma.

The injured person may push others away to protect themselves, just as I have done. It feels easier than letting others close enough to risk hurting our already wounded soul. So, we suffer in silence, cover up our pain, and paste on a smile.

Difficulty Making Decisions.

Both Big 'T' or little 't' trauma, can have significant impact on one's life.

A person that has suffered any type of trauma may have problems functioning. They may struggle making decisions and moving forward with life. Their world has been turned upside down and because of that, nothing makes sense. Things that they once could do easily are now hard for them.

Trauma can impact every decision we make. Even if we think we have our trauma "under control" we may need some guidance in this area.

Recovery Time.

There is no recovery timeline for trauma, which can be frustrating. If we were told that our souls were wounded and it would be 6 weeks before we were feeling better, it would be easier. But no one knows how long it will take.

Because we cannot see the bleeding, we are only so patient with our own recovery. We start to think we should have moved on already and start using coping mechanisms to mask the pain.

Things like overworking, overeating, isolating, and burying our emotions. Which only works to keep us from processing our emotions.

Trauma Tools.

Emotional Swamp.

I tend to want to skip over the hard parts of life. I want the story to go like this. This was hard and then they lived happily ever after. I don't want to wade through the emotional swamp that is trying to suck me under. So, I try to hop over it and go happily along in my life. "The Lord loves a cheerful heart" and all of that.

However, the truth is we have to wade through the muck to get to the other side. Every. Single. Time.

When we ignore the yucky stuff, we can get stuck in the trauma.

Acknowledging Pain.

We want to ignore our painful past and pretend it didn't happen. We definitely don't want to look at it directly and feel the pain slapping us in the face. To do that would be to acknowledge the trauma.

We are so afraid of feeling that we hold it inside, so we don't have to feel it or see it. Keeping our feelings locked up means we pack around a molten stone of pain that is burning a hole in our hearts.

Journaling.

Journaling is a powerful way to heal from our experiences. When we record our raw and real thoughts and feelings, we see our truth. In recent years, research has shown that journaling helps people with PTSD in several diverse ways. Psychologically, expressive writing helps people better cope with the symptoms of PTSD, such as anxiety and anger. Physically, journaling can make a difference as well, reducing body tension and restoring focus.

Journal to record your experiences. Be open and honest about it. Look for what you learned during a particular battle and record that as well. Journaling leads us to growth.

Reframing.

When we journal, we can see our stories. As discussed in chapter 7(Doodle Stories) we are wired to create stories; they help us understand our lives. However, we add our own emotional flavor to our story. Some stories are painful, and we add to the pain by telling ourselves we aren't good enough, we should be embarrassed, and that we should give up. And we **believe every word.**

We may want to change our past. But there is no going back. There is only forward, toward healing. Through telling our story of victory we gain traction over our trauma and therefore our lives.

Remove the Labels.

Many times, we believe the trauma is who we are. We have taken our trauma and glued it to our faces. So, we don't see life clearly. We just see the trauma.

We forget who the girl is underneath it all. There is no freedom, joy, or hope there. There is just existence.

What labels have you accepted as yours?

Labels start with I am…

Worthless.
Victim.
Depressed.
Anxious.
Angry.
Weak.

These are just thoughts. We create our reality. We can remove the victim label by exchanging it for empowering labels.

Such as I am…

Strong.
Victorious.
Courageous.
Brave.
Powerful.
A fighter.

How Doodles Heal Trauma

Doodling Helps Trauma Heal.

When it comes to trauma survivors, the healing process is different for everyone.

While some turn to prescription medications, others are looking to alternative methods to help them live better and more fulfilled lives. Alternative methods can include doodling, sketching, and journaling. These tools help a person organize their thoughts, feelings, and emotions. Art therapy has long been used therapists' offices to help children to process their emotions. It turns out it is great for adults as well. By doodling our thoughts and feelings we can see what we are thinking and feeling.

Doodle Healing.

Doodle Healing is a powerful tool to begin healing our wounded souls.

Doodling allows us to express our emotions.

Doodling gives us the opportunity to express difficult emotions in a safe, creative environment. Doodles can provide an outlet for emotions that may be difficult to verbalize.

Helping us express our feelings in a non-verbal way, which is a powerful tool for healing and transformation.

Doodles provide a visualization of the trauma and allows us to become a compassionate witness to our experiences. This allows us to gain insight and understanding while processing painful memories and experiences.

Process Painful Memories.

Doodling encourages self-reflection and helps people gain greater self-awareness, self-confidence, and self-esteem. Doodles provide a safe, neutral place for processing thoughts and emotions.

Doodling translates painful memories and experiences into doodles, words, colors, and textures. Making it easier to process our trauma.

Doodle art therapy allows us to gain insight into our experiences and helps us make connections between the past and the present. Doodles help us gain clarity about our thoughts and emotions surrounding the trauma. This allows us to separate what happened to us from who we are. Giving us the power to take control of how we proceed.

Doodles Improve Self-Esteem.

Doodle art therapy helps us develop healthy coping strategies, such as relaxation techniques and mindful breathing. It can also be used to create a sense of safety and calm, reducing the intensity of trauma-related symptoms.

Doodle art therapy also gives us permission to rewrite our stories. Many times, we believe we are stuck in the past. But we don't have to be. We can rewrite our story through doodles and see an entirely different experience. An experience that creates a warrior instead of keeping us as victims.

Processing Trauma.

Doodling changes our brains because we get our thoughts out on paper. While journaling is great, creating doodles makes journaling one hundred times more powerful. It helps create a perspective we might not have considered before.

Doodles gave me power to author my own story. To step out of the victim mentality and let go of the past. My past story became my warrior story. Allowing me to create a future on purpose.

Doodle Healing is a fun, easy, and effective way to heal your heart.

Trauma Storyboard

Doodle Compassion.

In the book *"The Body Keeps the Score"*, the author writes that the power of art, music, and dance help us overcome our inability to put words to our trauma. Doodle art therapy helped me put words to my trauma.

I used doodles to create a storyboard of my childhood trauma. Doodling my trauma was very powerful. I doodled my 8-year-old self, my 18-year-old self, and my 35-year-old self in the doodles.

The compassion I felt for myself was overwhelming. This doodling trauma exercise gave me the ability to step back, see the situation, and grieve. Allowing myself the space to feel my emotions both then and now.

Doodle Trauma.

Using the storyboard was a powerful way to process my childhood trauma. The following doodles are how I saw the events in my life.

After being diagnosed with Multiple Sclerosis or MS, my mother became an invalid within 6 months. The events from diagnosis to her death, guided the three-panel storyboard: The first panel shows me at 8-years-old as my mother's caregiver.

An 8-year-old me as my mother's caregiver.

28 years old

8 years old

The second panel I am an emotionally checked out 18- year-old.

I am an emotionally checked out 18-year-old.

38 years old

18 years old

In the final panel, my mother is dying. I have left my mother's bedside. land wish she would just die already.

> **I have left my mother's bedside. I am wishing she would just die already.**
>
> Temp 106°
> 56 years old
>
> *Is she dead yet?*
>
> 34 years old

This exercise created the feeling of deep compassion for myself and for my mother.

Doodle Hero.

The magic to this process is to repeat it. I started the process again. Drawing the characters again but making tweaks of how I wished the situation could have been different.

It is interesting what our brains can do. The first box, I doodled my mother acknowledging my pain. This created a powerful shift for me. The next box showed my mother and I bonding despite her remarrying.

In the third box I cried while standing beside my mother and holding her hand. Instead of turning away.

The last doodle, I stood by her death bed as I mourned her death.

Storyboarding allowed me to walk through this experience and have different emotional responses.

Imagine Something New.

This experience is worth spending time on. The mind doesn't know the difference between actual experiences and imagination. We resist imagining good things because we believe imagination is childish. However, we use our imaginations every day to keep us in fear, anger, worry, and shame.

However, we can use our imaginations for creating feelings of joy, excitement, and peace.

This technique doesn't change the past. However, by imagining a different outcome, reaction, or emotion, we can change the way we feel about the past.

For example, when I created my second storyboard the boxes looked like this: On the first panel, I doodled my mother explaining what was happening while she held my hand. I felt safe and loved.

My mother explaining what was happening while she held my hand. I felt safe and loved.

28 years old 8 years old

The second panel I imagine myself holding my mother's hand. And interacting with her in a normal mother daughter way.

Creating a relationship with my mother.

38 years old 18 years old

And the last panel is how I imagined myself interacting with my mother as she died.

Holding my mother's hand and grieving her death.

34 years old
56 years old

You Hold the Power!

Our memories are not as accurate as we think. Over time, our memories morph and change. We hold on to our perception of reality, but the past is but a memory. An inaccurate memory at that.

Humans can imagine and create new things. This means we can change how we remember our past so we can create a new future. Our imaginations can be our superpower or our Kryptonite.

It's your turn to create a new past. This is not letting someone off the hook. This is about using your imagination to start healing your wounds and living in the world a entirely different way.

Try it! I would love to know how it went!

Doodle Activity
Storyboard Healing Doodle.

Doodle along with me as we dig deeper into the parts of us begging to be heard and seen. We will allow ourselves to remember the events that hurt us and doodle the hurt. Then we will doodle a new story, one our former self often wished for. Our brains don't know the difference between truth and imagination. This is a powerful exercise that helps heal our wounded souls.

Supply List:
- 2 Mixed media paper or cardstock paper.
- Watercolors, crayons, markers, etc.
- Pencil.
- Waterproof fine tipped marker.

1. Place your paper horizontally in front of you.
2. Journal prompt: What life occurrence would you like reframe.
3. Make one line down the center horizontally and another vertically. (You should have 4 rectangles.)
4. Starting with my seven-year-old self, I doodled what that looked like for me. My doodle was a sad little girl standing by her mother's wheelchair.
5. Then the next frame shows me at fifteen-years-old feeling left out as my healed mother and her new husband hold hands.
6. The third frame is of a seventeen-year-old standing away from her mother's wheelchair.
7. And the final box is of my mother dying. I stood with my back to her wondering when she would finally die.
8. Repeat the above for your personal experience but on the second time around reframe how you wish things had been different under the circumstances.
9. You are welcome to paint or color yours. I did not paint mine. The process was raw and I stopping at just the doodling seemed enough.
10. Yes, I know it's not true. But our brains believe what we tell it to believe. Creating this doodle starts the healing process.

My old story kept me stuck and in pain. I felt guilty, lonely, and ashamed for not showing up like I thought I "should" have.

The new story I imagined. This story helped me start to change the relationship with my mother. And start the healing process.

To access the free Doodle Art Therapy Workbook, go here: https://doodletherapy.groovepages.com/book-free or use this QR code. The workbook is a great place to journal about a wound that doesn't want to heal.

11
Doodle Focus

"Always remember your focus determines your reality."
~George Lucas

Red.
Surprise!!

From my basement office, I could hear the excitement of my children. They beckoned for me to come and see. I cautiously moved toward the stairs. I didn't trust my children… And for good reason.

As I emerged from the basement, my youngest son, William stood before me. He held an adorable, red, squirming puppy he had already given a name. The puppies name was "Red."

It had only been 2 years after our marriage nearly ended. Our family was still struggling financially, emotionally, spiritually, and mentally. There was no way we could handle a puppy.

I firmly said, "No, we can't have another dog." My husband entered the room echoing my feelings.

Promises. Promises.

William was fourteen that summer. He promised to be a responsible pet owner. He would feed, water, train, and bathe the puppy.

Two of his sisters "ahem" (accomplices) pledged their undying support. Those sisters even promised to care for the puppy when Will graduated from high school.

Lyle and I knew these were hollow promises at best and lies at worst. "No" was the final answer. William was told to return the puppy to the box he had found her in.

William quietly picked up the puppy and disappeared into his bedroom. Presumably to say goodbye.

Invisible Puppy.

When I say disappeared, I mean vanished. The puppy was gone. We couldn't figure out what happened, and William wasn't talking. We didn't see the puppy leave, hear a puppy sound, or see a puppy dropping. So, obviously we assumed the pup had been returned.

However, weeks later the puppy was spotted tucked in William's arms. William had decided that despite his parents' objections. William had decided that Red was already home.

Our son knew Red would be returned if we found her. So, the pup became Will's one and only focus. He took her wherever he went. He fed, trained, bathed, and slept with Red.

Focus On Red.

Because Red became William's one and only focus, Red learned how to act in the house, was well cared for, and became a member of our family in record time.

However, if William had focused on more than his puppy, he would have failed to keep her. The unsupervised puppy would have misbehaved in the house, not been cared for, and consequently returned to the box she came from. Because William focused on what he wanted, he got to keep his puppy. This made me ponder on how I was or was not making progress in my own life.

Focus On One Thing.

You see, I love learning new things. However, my tendency to rush through lessons, in my eagerness to move on to the next topic, hampers my progress. I fail to implement what I've learned, leaving me without much change.

To get where you want to go faster, focus on just one thing!

I wondered: What if I focused on just one thing like William focused on his puppy. What if I carried my new habit with me wherever I went, slept, and ate with that new habit, until it became a part of me? What kind of progress could I make?

My brain wants me to believe that by focusing on one thing, I'll fall further and further behind. However, I decided to see what would happen if I focused on one thing.

The One Thing.

Focus On One Thing.

With so many options vying for our attention, it can be daunting to choose just one thing to focus on. The struggle to commit to our hopes and dreams often leaves us feeling stuck and unable to make meaningful progress towards our desired destination.

When I attempt to travel down ten paths simultaneously, I can only take one step on each. However, when I take ten steps on a single path, my progress becomes exponential.

This focused approach not only boosts my confidence but also propels me forward with unprecedented momentum, far surpassing anything I could have imagined.

Choices.

But deciding which path to pursue can be a daunting task. How does one relinquish the other desires and responsibilities that fill our lives? Many of us find ourselves trapped in a state of indecision, unsure of which direction to take. Personally, everything feels equally important, making it challenging to choose one and let go of the rest.

Consequently, we opt for indecisiveness and go with the flow. By allowing life to happen to us, we surrender our power to intentionally create the lives we desire.

Victims.

When we fail to make decisions about our future, we cast ourselves into a victim role. Becoming passive observers, ill-prepared and waiting for life's next blow to strike. We justify our lack of action by attributing our circumstances to external factors. We convince ourselves that the outcomes we experience in life are not our responsibility, but the cards we were dealt.

But here's the truth: We have the power to shape our destiny. By embracing accountability, we can break free from the victim mindset and reclaim control over our lives.

It's time to discard the notion of being a mere bystander and step into the role of the deliberate architect of our future.

Play Around the Edges.

I once believed that I lacked the ability to achieve my goals. In my mind, a goal was something I truly desired.

However, I consistently struggled to make real progress. I experimented with various strategies, such as writing the goal down, sharing it with others, creating a detailed plan, and taking small steps forward.

Yet, time and time again, I found myself giving up before I could achieve substantial results.

I leaned on excuses to justify my failures. Maybe someone didn't believe in me, I had other commitments that took precedence, or I lacked the time were excuses I used for my shortcomings.

What excuses do you use?

What Do **YOU** Want?

It's interesting how we often resist the thoughts and ideas of others when it comes to our choices, yet we readily use their opinions and actions as excuses when we feel like giving up.

Friend, it's time to stand up for yourself. It's time to advocate for what you want and take bold action towards it. No one can do it for you. You must be willing to put everything on the line, let go of the limitations that hold you back, and take control of your life. You possess the power to transform your destiny. Embrace it wholeheartedly and sprint towards the life you desire.

> **Sprint towards the life you desire.**
> *Cindy Bayles*

What You Focus on Grows.

Rock Bottom.

When my life hit rock bottom, there was no direction to go but up. However, I could only focus on taking one step at a time. So, I focused on practicing gratitude. It became my one thing, my chosen path. Each day, I challenged myself to find three things to be grateful for. At first, I found myself repeating the same three things, but I dug deeper. I noticed blessings I had taken for granted, didn't feel like blessings, and often complained about.

Are you choosing your future on purpose?

Cindy Bayles

Choose Your Path.

In Chapter 3 (Doodle Joy), you can read more about seeking joy. Practicing gratitude became the foundation on which I rebuilt my life. I built a life filled with unimaginable joy, love, hope, and compassion.

This book holds timeless principles, but trying to implement them all at once can feel overwhelming. But we can't take more than one path at a time. We make progress faster and retain it longer when we focus on implementing one thing at a time.

Create On Purpose.

In Ben Hardy's book *"Personality Isn't Permanent,"* he reveals that our personalities are ever-changing. We are not the same person we were five years ago, and our future selves will be different in five years. We are in a constant state of learning, growth, and evolution.

Unfortunately, we often believe that our personality is fixed. We rely on personality tests, human design, and childhood labels to define ourselves, thinking we have no control over who we are. However, we have the power to intentionally create ourselves.

Don't let your primitive brain shape your future.

> **We rely on personality tests, human design, and childhood labels to define us. Thinking we have no control over who we are.**
>
> *Cindy Bayles*

No Wrong Choice!

But where do you start? The answer is simple: **wherever you want to.** There is no wrong starting point. When you choose to focus on one thing, the impact is exponential. Your new habit will grow and impact other areas of your life as well.

It's easy to make a choice and then doubt ourselves so we choose something else. Never giving our new habit the time and attention, it needs to grow and develop.

Recently, I attended an event I had been going to for nine years. Throughout those years, we would arrive late, sit at the back, and leave early. We rated the experience as average.

Be All In!

This past year, we made a significant shift in our approach. We stopped playing around the edges and jumped in.

We showed up differently by:
Volunteering to lend a hand.
Arriving early.
Choosing seats in the front.
Engaging with other participants.
Staying until the end.

By showing up differently, our entire experience transformed. We had an incredible time and couldn't believe we had missed out on so much fun for so long.

The way we show up matters. Imagine the possibilities if we cultivated a single habit. We nourished it, nurtured it, gave it love, and allowed it time to grow.

Give It Time!

Don't Rush.

Contrary to the desires of my impatient mind, habits are not formed overnight. It takes time for new actions to become ingrained habits.

That's actually positive. Imagine if a new habit were formed after doing it once.

Our brains require time to establish new neural pathways. The intensity of the emotion associated with an action determines how quickly a habit is formed. By deliberately cultivating a sense of celebration, we strengthen the synaptic connections in our brains.

When we are intentional about the habits we choose to cultivate, we intentionally shape our lives. We have the power to create the life we desire, creating habits on purpose.

Consistency.

Consistency is key when it comes to developing new habits. By giving consistent attention to our desired habits, we train our brains to adapt. When triggered, we act and then celebrate that action.

Being intentional about the prompts is crucial. We need to disrupt the ordinary and introduce something that prompts us to act. For example, laying out our workout clothes the night before, posting the menu on the fridge, or placing a rock on our pillow.

These triggers disrupt our usual routines and serve as reminders to take action, reinforcing the habit we are trying to cultivate.

Accountability.

It's easy to let ourselves down. To go the extra mile, we can use forcing functions to keep us accountable. A forcing function would look like hiring a trainer, joining a membership, making a bet, or setting a deadline with consequences.

Forcing functions force us to show up because we have someone or something to answer to. They provide external motivation and accountability. Think about what would help you show up for yourself.

Find a workout partner, join a group, share your goals publicly, or have regular check-ins with a mentor or coach. By using external factors, you strengthen your commitment and increase your chances of winning.

Celebration.

Sometimes, I'm tempted to skip the celebration. It seems like a waste of time or even silly. But trust me, it's crucial for solidifying the new habit in your brain.

Celebration is like magic—it strengthens the neural pathways associated with the habit, making the process smoother, more efficient, and longer-lasting.

Here's a clever tip: Try doing the activity once, and then immediately repeat it. It's like getting two for the price of one!

I challenge you to give it a try and experience the power of celebration for yourself. Don't underestimate its impact on making your habits stick.

Magic Habits.

It's magical when your new habit becomes automatic. The worry of remembering, staying motivated, or forcing yourself, simply fades away. Your brain takes over and makes it easier for you.

> **Celebration is like magic–it strengthens the neural pathways associated with the habit. Which makes the habit stick.**
>
> *Cindy Bayles*

Isn't it exciting? With a little intentionality, I can reprogram and program my own brain. I don't have to be at the mercy of unintentionally created habits. I have the power to change old habits by creating new ones. It's all within everyone's reach.

Habits Are Your Life.

Blessings And Curses.

Our habits have the power to either bless or destroy our lives. Empowering habits eliminate the need to rely on motivation. They become our allies, making our lives easier and more fulfilling. To gain clarity on our habits, it's valuable to take inventory.

Create a list of all the habits you currently have. Then, consciously evaluate each one and determine which habits are serving you and which ones are holding you back. This process allows you to be intentional about which habits to keep and which habits to let go of, enabling powerful transformation in your life.

Easy Does It.

Our brains naturally seek to make our lives easier by forming habits. Brains are trying to avoid expending unnecessary energy on relearning what was already learned. However, if we rely solely on our brains to remind us of the changes we desire, we make the process more challenging than it needs to be.

To ensure success, we can set ourselves up by implementing triggers that prompt the desired action.

Additionally, breaking the action into small and simple steps makes it more manageable. By celebrating even, the smallest of actions,

we reinforce positive progress and create a sense of accomplishment. This approach simplifies the habit-building process and increases the likelihood of long-term success.

Tiny Is Mighty.

In the beginning of the year, it's common to feel enthusiastic and motivated to make changes in our lives. However, it's important to pause and consider a different approach.

Instead of diving into grand plans, focus on identifying the smallest possible changes you can make. Although it may seem counterintuitive, this is how our brains operate most effectively.

By creating a plan that prioritizes lasting changes in our brain, we can avoid the pitfalls of quitting. Often, we struggle to sustain our efforts because we set ourselves up with daily tasks that are too challenging to maintain. Taking small, manageable steps can lead to sustainable progress and long-term success.

Purposeful Action.

Before discovering the power of **intentional habit creation**, I was unaware that my brain was developing new habits on its own.

To regain control, I embarked on a journey to rewire my brain using the tools in this book. I wanted to transform my brain into an ally.

One area where I desired change was in my weight. I began by brainstorming various approaches and identified the simplest option: recording everything I ate. It may sound too basic, but that single habit shift had a profound impact. Over the course of six months, I successfully shed 30 pounds.

This experience taught me the potential of intentional habit creation and the transformations that occur with even the smallest of changes.

> *Is this habit serving me?*
>
> **Inventory your habits. Examine what habits are serving you are which need to be discarded.**
>
> *Cindy Bayles*

What Will You Create?

Take a moment to envision how you want to shape your life. What small, incremental habit do you wish to begin nurturing?

Consider the possibilities that would arise if your focus this year was on cultivating more joy.

Often, our impatience drives us to take on too much at once. Instead, imagine the impact of taking the tiniest of steps forward each day.

What if you could ingrain the new habit into your brain to the point where it becomes who you are?

Reflect on a habit that will enhance your life in ways you never thought possible.

Imagine a life that is both better and easier, fueled by a seemingly simple new habit.

Doodle Activity
What You Focus on Grows.

Doodle along with me as we intentionally plant a thought seed and focus on its growth and nourishment. This doodle helps to internalize the fact that it takes time and attention to create new thoughts and beliefs and that is O.K.

Supply list:

- 1 1/2 sheets mixed media paper or cardstock paper.
- Watercolors.
- Pencil.
- Waterproof fine tipped marker.
- Scissors.

1. You will need one full-sized piece of paper and a smaller half page.
2. Doodle you with a watering can. You can doodle this on the page or cut a separate one out. I like cutting her out so I can move her around.
3. Doodle a horizontal line across the page.
4. Doodle a sun in the left-hand corner.
5. Doodle a seed planted in a hole. (This is the seed or goal you are growing.)
6. Doodle the seeds roots growing. (Your idea begins to grow.)
7. Doodle the seeds root growing bigger.
8. Doodle the new growth peeking out of the ground.
9. Doodle the seed with a leaf.
10. Doodle a bud on the plant.
11. Doodle more leaves and a small flower.
12. Doodle the flower maturing.
13. What did you grow?

What You Focus On Grows

This is an unfinished Doodle Vision doodle. You can use it as a guide, finish it, or color it. The girl is meant to be cut out and moved along as the flower matures and grows.

To access the free Doodle Healing Workbook, go here: *https://doodletherapy.groovepages.com/book-free* or use this QR code. You can see the finished doodle focus doodle activity in the workbook in full color.

12
Doodle Warrior

"When you conquer the mind's battlefield, you can overcome anything."

~Cindy Bayles

What Is a Doodle Warrior?

Warrior Women

I planned on starting this chapter with a story of a woman who overcame hard things. However, as I sorted through various women in my life, I knew I could do better.

The fact is we are all warriors. Warriors who have been through battle. Warriors who have overcome hard things.

Devastatingly hard things. Warriors who have suffered great loss. Warriors who have felt hopeless. Warriors who have been wounded. Warriors who have wondered if they are worth the effort.

This book was written for you. **Women warriors.**

Battle Scars.

Every warrior carries battle scars. In my quest for the perfect life, I avoided any signs of imperfection I.E., scars. But, playing it safe doesn't make us stronger. Mistakes are part of learning. Think about learning to ride a bike, read, write, or walk. We stumbled along the way, but we kept going. Failure is giving up.

Instead of fearing mistakes, we can embrace them as growth opportunities. Our scars tell stories of strength and courage. Each one reminds us of the grit it took to get here. When we learn from our imperfections, we become stronger women, warriors, and humans.

> **Our scars tell stories of strength and courage. Each one reminds us of the grit it took to get here.**
>
> *Cindy Bayles*

Warriors Are Courageous.

Warriors don't hide; we have overcome our greatest fear – being seen for who we are. Embracing every part of ourselves with love and acceptance, we recognize our greatness.

Warriors live life boldly, authentically, and purposefully.

We possess the strength to endure, courage to embrace mistakes as opportunities, and seek experiences that challenge our comfort zones.

> Your
> greatest fear

Warriors don't hide; we work to overcome our greatest fear – being seen for who we are.

Cindy Bagley

Warriors Are Prepared.

Warriors make plans. Plans that get them where they need to be. They decide what they want, why they want it, and how to get what they want. Doodle warriors are prepared for obstacles.

Warriors arrive equipped and ready for the battles ahead. We are indifferent to opinions, comparisons, and challenges. We don't complain and take charge of our destinies.

You Are A Warrior.

As warriors, we fight unseen battles. Encountering battles that test our strength and resilience. As we navigate life, we may be weary, wounded, and tempted to surrender. However, now is not the time to retreat. This is the moment to rise up and confront our opponent. The enemy that wants to see us fail.

What stands in your way of becoming your highest and best self?
Fear?
Inadequacy?
Hopelessness?
Self-criticism?
Negative Thoughts?
Lack of self-care?
Let's conquer these together.

Warrior Strategy.

Where are You Now?

When we feel helpless and powerless, it is easy to get stuck. We might blame others for our problems, make excuses for mistakes, or feel powerless to move forward. When we take responsibility for where we are now. It allows us to look at our situation objectively and develop a plan moving forward.

When we take the time to assess our situation, ask for help from others, and invest in our growth, we break out of feeling powerless and create a brighter, more fulfilling future.

Where Are You Going?

Once we know where we are, we need to know where we are going. This is when our plan starts taking shape.

Like the Cat said in <u>Alice in Wonderland by Lewis Carroll</u> —
'If you don't know where you want to go, then it doesn't matter which path you take."

However, if you know where you are going, then every step matters. Each step takes you closer or farther from your goal.

When you know where you are going, every step matters. Each step takes you closer or farther from your goal.

Cindy Bayles

What Must You Overcome?

We keep ourselves small when we believe, "I could never do that". What would happen if we turned this statement on its head? Just because you have never done something does not mean you can never try something new.

This is just an excuse to not stretch ourselves. Or when we take a step closer to who we want to be, say, "THAT is just like me." And every time we mess up, say, "That's not like me!" This simple hack changes results. Change your words. Change your life.

What Is in Your Way?

When we are afraid of failure, we are frozen in place. Believing that mistakes are kryptonite. When the opposite is true. Mistakes may expose our weaknesses but when we overcome them, we gain power and strength.

We can be our own worst critic. We tell ourselves how we can't try something new. That we aren't good enough. And don't embarrass yourself. Stop the chatter already. The chatter is trying to protect you, but it is your job to decipher the truth. And "you can't do that." Is a lie.

Battle Plan.

> **The chatter is trying to protect you, but it is your job to decipher the truth. And "You can't do that." Is a lie.**
>
> *Cindy Bayles*

- You are not good enough
- Who do you think you are?
- Don't embarrass yourself
- It's too late to start

Being a warrior is about taking charge of your life. A warrior has the courage to face each challenge. They choose how they will handle their circumstances and have the confidence to move forward despite their fears and excuses. Warriors are resilient, determined, and never give up. They understand that life is full of challenges, and they keep fighting even when faced with adversity.

Powerful Warriors

Doodle Power.

Doodling is a vital tool for warriors, thanks to its speed and effectiveness.

Doodle Power

Change your brain

400% Faster!

It cuts through limited thoughts and introduces us to fresh ways of interacting with ourselves and the world.

The power of play has been proven to enhance learning by a staggering 200%! While it typically takes 200 repetitions to form a new brain synapse, doodling reduces this number to just 8-10 repetitions.

That's why I love doodles—they create new neural pathways faster and more efficiently than anything else.

Doodling accelerates our understanding and transforms how we learn.

Care of a Warrior.

Warriors take responsibility for their own healing, happiness, and lives. They let go of blaming, controlling, and expecting others to change so the warrior can feel better. Warriors intentionally create their days, their destiny, their well-being, and their thoughts. In so doing, they become architects of their own lives.

Warriors guard their thoughts because they know what they think creates their results.

Warrior Language.

I choose to

I can learn something new

I can figure this out

What can I learn from this?

Words Matter!

Cindy Bayles

Warriors are intentional with their language. Instead of, "I must," a warrior says, **"I choose,"** reclaiming their agency. Rather than limiting themselves with "That's just how I am," they ask, **"What can I learn from this?"** This stretches them to learn from any situation.

Warriors embrace their worth by accepting compliments with a simple **"Thank you,"** embracing their value.

When faced with challenges a warrior replaces "I don't know how" with **"I can figure this out,"** bolstering their confidence. A warrior declares **"I choose this."** Instead of giving up their power by thinking "I have to." By using simple language shifts we can embody our warrior within.

Warrior Power.

By embracing the language of a warrior, we see ourselves as powerful and engage with life courageously. Using intentional language shifts, I have transformed how I see myself. I recognized my worth and embraced positivity by accepting compliments without apology.

When faced with uncertainty, I intentionally replace *"I don't know how"* with the belief that **"I can figure this out."** These language shifts allow me to own my choices, embrace growth and learning, and stop making excuses.

As a warrior, I know my words shape my reality.

Warrior Expectations.

A study conducted at Stanford, Columbia, and Yale shed light on the effect of setting high expectations. The researchers discovered that when teachers gave feedback that conveyed a strong belief in a student's potential, their effort and performance significantly improved.

The teachers randomly put sticky notes on the papers. One set said, "I am giving you these comments so that you'll have feedback on your paper." The second set of words were:

"I'm giving you these comments because I have very high expectations and I know you can reach them."

It is amazing that eighteen simple words could make such a difference. What was the difference, you ask? Well let me tell you.

Warrior Study

Each student was offered the opportunity to revise their essays. What happened next is what makes this study interesting.

Among the white students, 87 percent of the students who received the encouraging note revised their essays, compared to only 62 percent of those who received the notes that just giving them feedback.

However, among the African American students, the effects were astounding. 72 percent who received the encouraging note revised their papers, compared to only 17 percent of the black students who received the "here's your feedback" note. AND the revised essays received higher scores!

This study shows the importance of what we say to ourselves and others. As warriors, we accept feedback because we **"have very high expectations for ourselves and know that we can reach them."**

> I'm giving you these comments because I have very high expectations and I know you can reach them.

You Are a Warrior.

Purposeful Warrior.

I can hear your cries, "It's too late for me! I am too old, and my time has passed!" But let me tell you, dear friend, as long as you draw breath, your journey holds purpose. Society's expectations of age, appearance, and conformity have deceived us for too long. What if we defy those expectations? What if it's never too late to create something new? The notion of time limits and social societal standards becomes irrelevant when we focus on making a meaningful difference, no matter your age, appearance, or economic situation. Embrace your unique path and let your impact reverberate far and wide.

Meaningful Warrior.

A research study found that a sense of purpose can be found in the midst of our daily struggles. It's clear that having a purpose

helps us to find a way to cope with adversity and gives us the strength to persevere even when hope starts to fade. Faith can provide us with a sense of purpose, as it allows us to find meaning in the details of our lives. It is inspiring to know that even in difficult times, we can use our purpose to guide us throughout our lives.

Age Of A Warrior.

The funny thing about humans is we think we are too old or think we are too young. We think we are too old, and no one will want us, or think we are to young and no one will care. In the end we are both wrong and right. Some people will want us, and some people won't. That's our brain trying to protect us.

Stop waiting to be chosen. Choose you and start chasing your dreams no matter what your age.

Stop waiting to be chosen. Choose you and chase your dreams no matter your age.

Cindy Bayles

Brave Warrior.

Warriors embrace responsibility for their lives, claiming their power to manifest miracles.

These miracles can encompass anything we desire. We may encounter obstacles, setbacks, and challenges, but with a strategy, we will reach our destination.

Miracles are not reserved for a select few; miracles are available to everyone. We all have a unique purpose.

However, it is in our hands to shape our future.

It is time to take the reins of our destiny, harness our potential, and deliberately craft our future.

Shine Warrior Shine.

Warriors embrace responsibility for their lives, claiming power to manifest miracles.

Cindy Bayles

Your Warrior Story.

Within each of us lies a warrior's story. What chapters comprise your tale? What challenges and adversities left their marks? What inner demons did you confront, while battling for your transformation? What ignited the flame within, propelling you towards an elevated version of yourself?

Remember dear warrior, you possess an immeasurable power, one that surpasses your understanding. Instead of seeking validation from the onlookers, it is time to recognize your worth. Embrace your story. Your story holds the key to unlocking your potential.

Anticipate Obstacles.

Never lose sight of your why. What is driving you towards your goal? Beyond mere financial gains, what outcomes do you seek to achieve? Whom do you aspire to uplift and support? What blessings do you want to invite into your life, and what limitations do you intend to let go of?

We must **anticipate obstacles.** Because there will always be challenges that lie ahead.

When confronted with roadblocks, we may think, "It is not meant to be". But **challenges are part of the process**, and through resilience and determination, **we can overcome anything.**

Craft an Action Plan.

It's time to create a strategy. Remember the saying, *"Planning to fail is failing to plan."* Begin by compiling a list of 20 essential tasks, prioritizing them based on their importance. Reflect on the impact of taking one small step forward each day for 20 consecutive days—what progress could be made?

Create a realistic and manageable strategy, one that allows steady progress. Once your plan is in place, diligently execute it, celebrating each small victory along the way.

Warrior Miracles.

Every time you do something on your list, say, "That's just like me!" Keep cheering yourself on! Keep expecting miracles. Watch for God's hand in your life. You are greater than you can possibly imagine. When you see God's hand, acknowledge his hand. And say, "That's just like HIM!" Look for God to show up in your life. What mighty miracle will you create together?

Prepare to be amazed by the frequency of His presence and support.

Manifesting Mighty Miracles

What miracles do you want to create? Imagine having a plan to cultivate self-compassion (Chapter 2), experience joy (Chapter 3), and nurture hope (Chapter 4). One step at a time, I transformed my life by intentionally designing a purposeful plan. I conquered the automatic negative thoughts in my mind (Chapter 5), examined the stories I told myself (Chapter 7), and prioritized my own needs (Chapter 6).

Embrace a bold and visionary approach to life (Chapter 8), allow yourself the time and space to heal (Chapter 10), while focusing on your personal growth (Chapter 11). These transformations are within your reach. I know because I manifested mighty miracles in my own life using these exact principles.

You, my friend, are a powerful warrior!
Never forget it!

Doodle Activity
Kintsugi Doodle

Doodle along with me as we doodle a mighty warrior. Kintsugi style. In Japanese culture when a vase is broken, they do not throw it away. But carefully put it back together with gold glue. These formerly broken pieces are stronger and more beautiful than they were before they were broken. The broken vases are believed to be of higher value than a vase that has never been broken.

Supplies needed:

- 1 Mixed media paper or cardstock paper.
- Watercolors.
- Pencil.
- Waterproof fine tipped marker.
- Glue or Mat Medium.

1. Cut your paper in half.
2. Doodle You. (Make her chunky.)
3. Paint your doodle and let her dry.
4. Cut your doodle out leaving space around her.
5. Tear your doodle into large pieces.
6. Glue her back together onto the other half of paper. Leave the torn edges showing. (Do not put glue on the front or it will smear the paint.)
7. Paint in the torn placed (scars) with gold paint or another color you like.
8. Write above her "I Am a Kintsugi Warrior".
9. And below her write "My scars make be beautiful and strong."
10. And on either side of her write some empowering thoughts. Here are a few ideas:

a. I am stronger and braver than I know.
b. It is possible that this happened for me.
c. I am capable, strong, and resilient.
d. I am not what happened to me.

Kintsugi Warrior

Doodle along with me a Kintsugi Warrior. We will use our scars to create a beautifully broken masterpiece.

To access the free Doodle Healing Workbook, go here:
https://doodletherapy.groovepages.com/book-free *or use this QR code. Download the workbook to see the full color finished Kintsugi Warrior.*

Please take a minute and leave a 5-star review on Amazon for **Doodle Your Healing Workbook.**
Share two things you loved about this book!
Together we can change the world.
Thank you!

♥ Cindy

ACKNOWLEDGMENTS

To Lyle for his eternal patience during the two and a half years it took to write this book.

To Kara for being brutal editing during the book's refining process. You pushed me to write a better book than would have ever been possible.

Thank you, Tiffany, for not giving up on me. Your tireless encouragement is what got me here.

My beta readers are so awesome! Thank you for taking

the

time to read the early edition of Doodle Therapy and give me your feedback, reviews, and edits. You encouraged me to reach for excellence.

I thank God for planting a seed and encouraging me to grow that seed into something I never imaged it could become. This book is a testament that miracles happen if we just keep showing up.

About The Author

Cindy Bayles is a life coach, mother, sister, friend, and author. She is the founder of Doodle Warrior University. A fun, easy, and effective strategy to design a life of joy, self-compassion, and purpose.

Because doodling changed Cindy's life, she wants to tell the world about it. So, she decided to write a book.

In her break-out book, Cindy Bayles has written a fun, easy, and effective collection of stories, doodles, and insights. She is a public speaker, a coach, and a woman determined to lift and encourage others to become their highest and best selves.

Cindy and her husband are in love with each other and the life they rebuilt together. They live in Blanding, Utah with their 3 dogs who think they own the place.

Connect with Me

https://www.facebook.com/cindykbayles/

https://www.facebook.com/doodlewarrior/

https://www.instagram.com/doodlewarrioruniversity/

https://www.doodlewarrior.com/

Doodle Warrior University

Want more life changing doodles?

Join Doodle Warrior University!

Click this link
https://bit.ly/doodlewarrior
or use this QR code to get on the wait list.

Get the Companion
Doodle Healing
Workbook

Doodle Your Healing Workbook & Doodle Healing were made for each other.

Get your workbook at this link:

https://bit.ly/DYHWorkbook

Or use this QR code:

Printed in Great Britain
by Amazon